Rubens & Company *Flemish Drawings from the Scottish National Gallery*

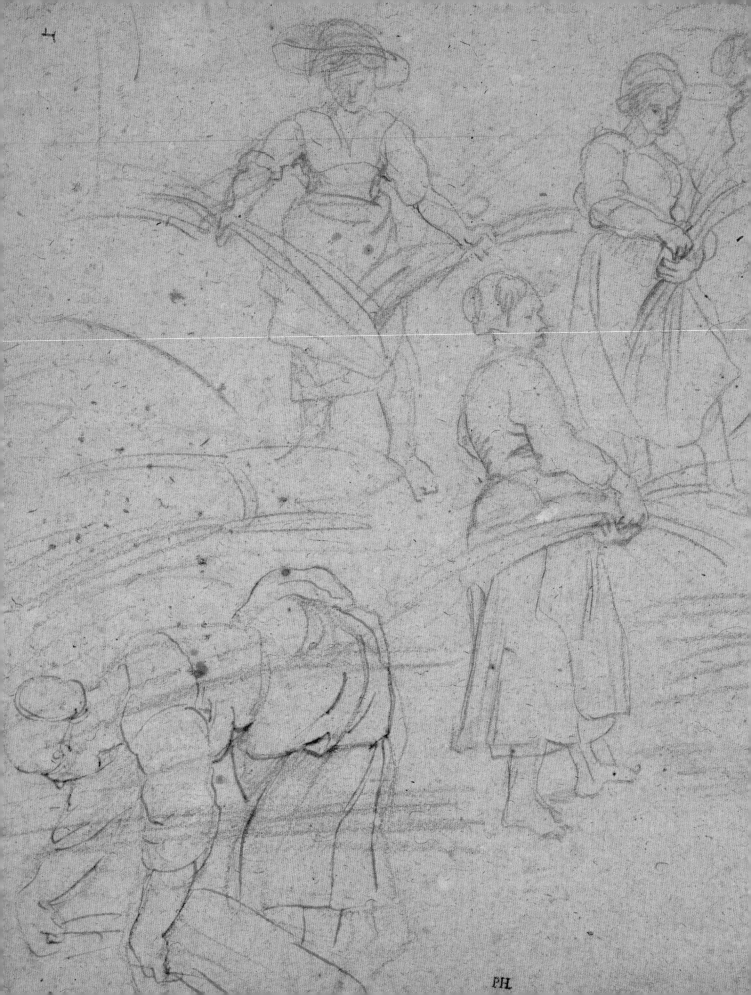

PH

CHRISTIAN TICO SEIFERT

Rubens & Company

Flemish Drawings from the Scottish National Gallery

NATIONAL GALLERIES OF SCOTLAND

Edinburgh · 2016

Published by the Trustees of the National Galleries of Scotland
to accompany the exhibition *Rubens & Company: Flemish Drawings
from the Scottish National Gallery*, held at the Scottish National
Gallery, Edinburgh, from 18 June to 28 August 2016.

Text © The Trustees of the National Galleries of Scotland 2016

ISBN 978 1 906270 98 8

Designed and typeset in MVB Verdigris by Dalrymple
Printed in Belgium on Perigord 150gsm by Albe De Coker

Front cover: detail from Jacques (Jacob) Jordaens
Head of an Old Woman, with a Ruff and a Cap (cat.6)

Back cover: Cornelis Schut, *The Massacre of the Innocents* (cat.22)

Frontispiece: detail from Peter Paul Rubens,
Eight Women Harvesting (cat.21B)

The proceeds from the sale of this book go towards supporting
the National Galleries of Scotland. For a complete list of current
publications, please write to: NGS Publishing, Scottish National
Gallery of Modern Art, 75 Belford Road, Edinburgh EH4 3DR,
or visit our website: www.nationalgalleries.org

National Galleries of Scotland is a charity registered in Scotland
(no.SC003728)

Foreword

The Print Room of the Scottish National Gallery houses some 35,000 works on paper which, due to their fragility and sensitivity to light, can only be displayed for short periods of time. This exhibition features an outstanding selection of Flemish drawings of the seventeenth century. Peter Paul Rubens, the towering figure of the Flemish Baroque, is central. His master-pieces are shown alongside famous works by Jacques (Jacob) Jordaens and Anthony van Dyck, accompanied by little-known drawings by artists such as Jan Cossiers, Abraham van Diepenbeeck and Cornelis Schut, which have rarely, in some cases never, been displayed before. Many of them are preparatory drawings or studies which offer a fascinating insight into the function of drawings as well as studio practice. *Rubens & Company* celebrates these artists and invites our visitors to discover and enjoy their skill in the art of drawing.

The exhibition has been devised and organised by our colleague, Dr Tico Seifert, Senior Curator of Northern European Art at the Scottish National Gallery. This publication was made possible through the generous support of the General Representation of the Government of Flanders in the UK, and that of Martin Adam and William Zachs, to whom we are deeply grateful.

SIR JOHN LEIGHTON
Director-General, National Galleries of Scotland

MICHAEL CLARKE
Director, Scottish National Gallery

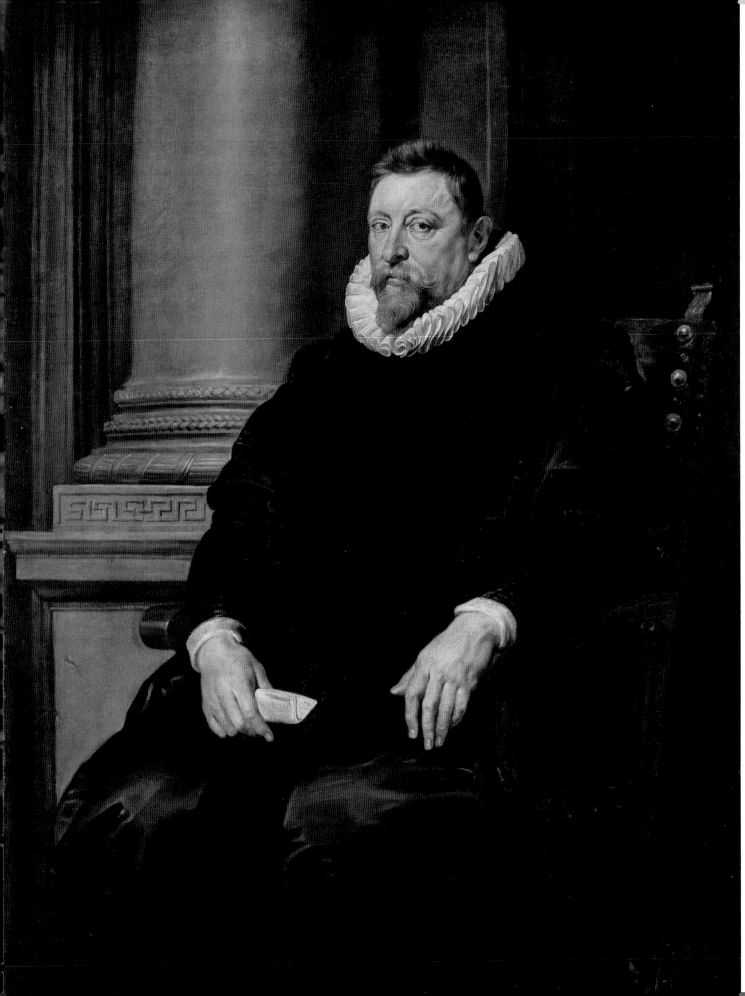

Rubens & Company *An Overview*

Today Flanders marks the northern, Dutch-speaking part of modern Belgium, an independent state since 1830. However, in the seventeenth century Flanders, together with Brabant, was the most prominent province of the Southern Netherlands, which were under the authority of the Catholic Habsburg kings of Spain. 'Flemish' was then widely used to describe the culture and people of this territory. Most of the artworks in the exhibition were created in the first half of the seventeenth century in Antwerp, the main port and economic centre located on the River Scheldt in Brabant. This was a period of considerable turmoil and uncertainty, due to the Eighty Years War (1568–1648) between the predominantly Protestant Northern and the Catholic Southern Netherlands, and the Thirty Years War (1618–48). Mobility among Flemish artists was high and many worked – at least temporarily – abroad, in Germany, France, England and Italy, where some of the drawings in the show were produced.

This exhibition presents a selection of Flemish drawings from the orbit of one of the greatest artists of all time, Peter Paul Rubens. The catalogue discusses the individual works, some of which are famous masterpieces by Rubens, Jacques (Jacob) Jordaens,[1] and Anthony van Dyck, others treasures by lesser-known artists such as Jan Cossiers, Abraham van Diepenbeeck and Cornelis Schut, that have rarely or never been publicly displayed before. This brief introduction follows Rubens's biography and puts these works and their makers in their historical context, demonstrating that Rubens was at the centre of a vast and powerful artistic, social and economic network.[2] Moreover, this introduction illustrates the National Galleries of Scotland's excellent holdings of paintings by Rubens and Van Dyck.

Fig.1 | Peter Paul Rubens, *Portrait of Petrus Pecquius (1562–1625)*, *c*.1615, oil on canvas, 157.5 × 119.4 cm
Scottish National Gallery, Edinburgh (NG 2797)

BEFORE ITALY

Peter Paul Rubens (1577–1640) was almost twelve years old when his mother and siblings returned to their hometown of Antwerp in 1589, his father having died two years before. Rubens was born in Siegen (Westphalia) and raised in Cologne, where his Catholic parents had fled in 1568 to escape religious persecution. Antwerp was dominated by Calvinists from 1566 until it was recaptured after a long siege by the Habsburg Governor Alessandro Farnese in 1585. Young Rubens was apprenticed to the local painters Tobias Verhaecht and Adam van Noort (who later became Jordaens's teacher and father-in-law) before entering the studio of the highly successful Otto van Veen, a learned artist who had spent five years in Italy. After about three years with Van Veen, Rubens became an independent master in the Antwerp Painters' Guild of Saint Luke in 1598. The *Calvary* (cat.13) probably dates from around this time, although the attribution to Rubens remains problematic. In the Holy Year 1600, Rubens left for Italy, as so many northern artists had done since the days of Albrecht Dürer, about 100 years before.

ITALY

Rubens first went to Venice in 1600, where he saw the great works of Titian, Tintoretto and Veronese, and then proceeded to Mantua. Probably provided with recommendations from Archduke Albert, Governor of the Spanish Netherlands, Rubens was appointed court painter to Vincenzo Gonzaga, Duke of Mantua, the same year. While he remained in the service of the Gonzaga throughout his Italian sojourn, he travelled widely and took on commissions elsewhere. The five drawings in the exhibition from his Italian period give a lively idea of his busy agenda; they relate to visits to Florence, Rome and Genoa, and to a first diplomatic mission to Spain, on behalf of Vincenzo Gonzaga. These works fulfilled different functions and show Rubens collecting, copying and emulating famous Italian models such as Michelangelo, Perino del Vaga and Raphael (cats 14, 16, 18). He also

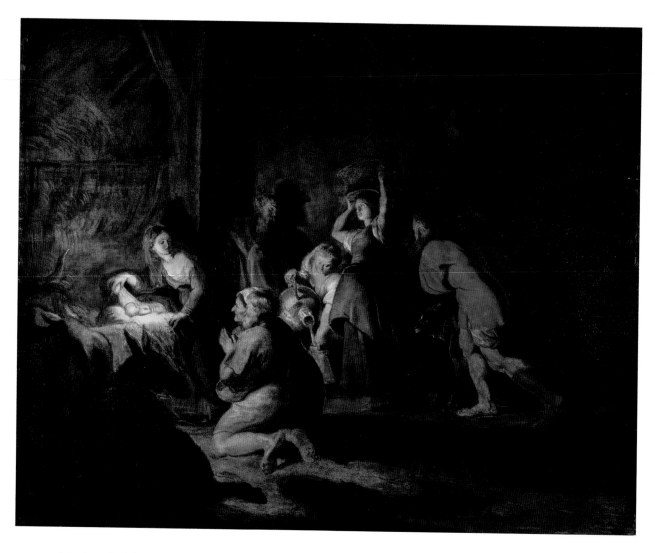

prepared designs for his own paintings (cat. 15) and for a print series celebrating Saint Ignatius of Loyola, commissioned by the Jesuit Order in Rome, which also employed the artist in Mantua and Genoa (cat. 17). Rubens's phenomenal international network of artists and humanists as well as rulers, patrons and collectors was established during his eight years in Italy. He absorbed the monuments of ancient Rome, the art of the Italian Renaissance and that of his contemporaries such as Caravaggio and Adam Elsheimer, and he continued to draw from these riches for the rest of his career. Rubens left Rome for Antwerp in 1608, hurrying to his mother's deathbed only to find she had died shortly before his arrival. He apparently had not expected to stay for long, but instead Rubens was to settle in his hometown, never to return to Italy again.

Fig. 2 | Peter Paul Rubens, *The Adoration of the Shepherds*, *c*.1614–16, oil on panel, 73.8 × 92.4 cm
Scottish National Gallery, Edinburgh (NG 2311)

Fig. 3 | Peter Paul Rubens, *A Study of a Head (Saint Ambrose)*, *c*.1618, oil on panel, 49.6 × 38.1 cm
Scottish National Gallery, Edinburgh (NG 2097)

SUCCESS IN ANTWERP

Within a year of his return, Rubens had married Isabella Brant (daughter of one of Antwerp's wealthiest citizens), established a busy workshop and been appointed court painter 'in absentia' to Archduke Albert and Archduchess Isabella, which allowed him to remain based in Antwerp. Also in 1609, the Twelve-Years Truce was signed, suspending the war between Spain and the Northern Netherlands and improving the economic situation of Antwerp considerably. Rubens was inundated with commissions from Antwerp and beyond. As a consequence, his workshop grew quickly and he bought a large house in the city centre.[3] The earliest painting by Rubens in the Gallery's collection is the *Portrait of Petrus Pecquius*, probably painted when the sitter was appointed Chancellor

of Brabant, in 1615 (fig.1). Official portraits such as this were often required in more than one copy, as gifts or for public display, and a workshop replica (repetition) of this portrait exists.[4] Also in 1615, the twenty-two-year-old Jacques (Jacob) Jordaens (1593–1678) became an independent master as a '*waterscilder*', a painter in watercolours – a skill that shows in several of the works in the exhibition (cats 7, 10–12). He also developed his own distinct artistic idiom as a painter in oils and a designer for tapestries. Although Rubens's work clearly left a mark on his art, there is no evidence for Jordaens having trained with him. Unlike Rubens and Van Dyck, Jordaens rarely left Antwerp and he took only a few princely and foreign commissions relatively late in his long and successful career.[5]

Anthony van Dyck's (1599–1641) early career is partly shrouded in mystery, but it is likely that he entered Rubens's studio after having trained initially with Hendrick van Balen in his hometown of Antwerp.[6] Precisely when he joined Rubens is uncertain, but possibly as early as 1611; he undoubtedly assisted the master in 1616–17. Apart from the *Portrait of Petrus Pecquius*, Van Dyck saw two more works from the Gallery's collection on Rubens's easel during those years. *The Adoration of the Shepherds* is a large oil sketch, its chiaroscuro reminiscent of Caravaggio's works (fig.2). There is, however, no painting known to have been executed after it.[7] Rubens's *A Study of a Head* (fig.3) is a preparatory study for the altarpiece *Saint Ambrose Refusing Emperor Theodosius in the Cathedral*. Van Dyck painted a smaller copy of the latter.[8] He enrolled as a master with the Guild of Saint Luke in 1618 but continued to collaborate with Rubens. Two years later, Rubens received his largest and most prestigious commission to date, comprising thirty-nine paintings for the ceiling of the recently built Jesuit Church (today Saint Carlo Borromeo) in Antwerp. The contract mentions Van Dyck as Rubens's leading assistant, responsible for the execution of the full-scale paintings, based on the master's oil sketch designs (cat.19).[9]

Fig.4 | Anthony van Dyck, *Saint Sebastian Bound for Martyrdom*, *c.*1620–1, oil on canvas, 230 × 163.3 cm
Scottish National Gallery, Edinburgh (NG 121)

Fig.5 | Peter Paul Rubens, *The Reconciliation of Jacob and Esau*, *c.*1625–8, oil on panel, 42.5 × 40.3 cm
Scottish National Gallery, Edinburgh (NG 2397)

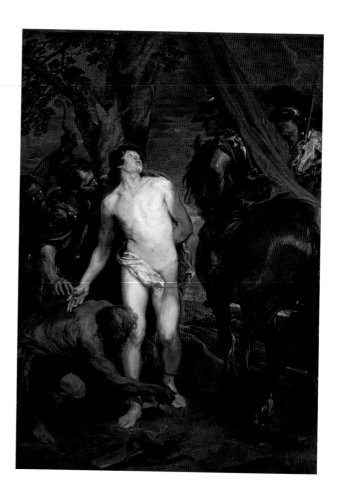

Both artists' productivity and energy seem to have been boundless in those years; Van Dyck painted his major *Saint Sebastian Bound for Martyrdom* (fig.4) around the same time.[10] Also during this period, in winter 1620–1, Van Dyck visited London and, only a few months after his return, he left Antwerp for Italy. Meanwhile, Rubens secured another monumental commission, for the *Medici Series*, celebrating the life of Queen Maria de' Medici, widow of the French King Henry IV. Rubens travelled to Paris several times between 1621 and 1625, when the twenty-four large canvases were installed in the Palais du Luxembourg. Immediately afterwards, he painted eight large pictures for Philip IV of Spain. *The Reconciliation of Jacob and Esau* is an oil sketch for one of them (fig.5).[11]

VAN DYCK AND OTHER 'FIAMMINGHI' IN ITALY
Van Dyck travelled widely in Italy during his six-year sojourn (1621–7), visiting amongst other cities Venice, Florence, Rome and Palermo. Genoa became his base, and there he painted the Gallery's portrait of an unidentified Italian nobleman as well as one of his grandest group portraits, *The Lomellini Family* (figs 6, 7).[12] It depicts the family of Giacomo Lomellini, Doge of Genoa from 1625–7, but does not include Lomellini's likeness as a tradition forbade portraits of the Doge while in office, to prevent personal propaganda.

Two other '*fiamminghi*' (as the Italians called the Dutch and Flemish alike) from Rubens's orbit were in Italy in those years, although it is unknown whether they had any contact with Van Dyck. Jan Cossiers (1600–1671) was in Rome in 1624, as was Cornelis

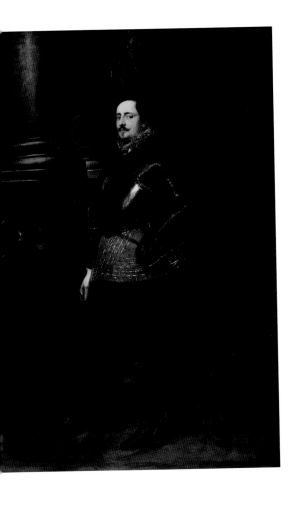

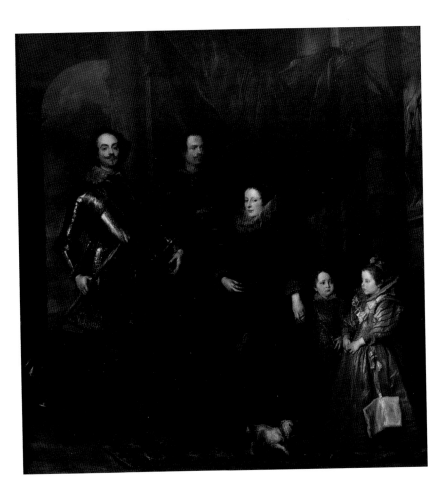

Fig.6 | Anthony van Dyck, *An Italian Nobleman*, c.1625–7, oil on canvas, 237.6 × 154.3 cm
Scottish National Gallery, Edinburgh (NG 119)

Fig.7 | Anthony van Dyck, *The Lomellini Family*, c.1625–7, oil on canvas, 269 × 254 cm
Scottish National Gallery, Edinburgh (NG 120)

Schut (1597–1655), who is documented as being there from 1624 to 1627.[13] Cossiers had trained in Antwerp with his father and Cornelis de Vos, a major portrait and history painter. He also spent time in southern France and visited Rubens's close friend, the astronomer and antiquary Nicolas-Claude Fabri de Peiresc in Aix-en-Provence, who recommended him to Rubens. The year after his return from Italy, in 1627, Cossiers enrolled as a master in his hometown. Cornelis Schut had already joined the Antwerp Painters' Guild before he set out for Italy. In Rome, he became a member of the 'Bentveughels' (Birds of a Feather), the society of Netherlandish artists (both Dutch and Flemish), and worked for a number of important patrons (cat.22). Like Van Dyck and Cossiers, Schut returned to Antwerp around 1627. While Van Dyck never collaborated with Rubens again, Cossiers and Schut were employed by Rubens for the huge commissions he took on in the 1630s (see below).

RUBENS, JORDAENS AND VAN DYCK IN ANTWERP

On his return to Antwerp, Van Dyck – not yet thirty years old and an internationally celebrated artist – established his own studio and received prestigious commissions, particularly for portraits (cat.4). The *Portrait of Marchese Ambrogio Spinola* depicts the famous Genoese commander in the service of Archduke Albert (who had died in 1621) and Archduchess Isabella. Spinola must have sat to Van Dyck in late 1627, as he left for Madrid on 3 January 1628, never to return to the Netherlands (fig.8). Long regarded as a studio replica, it has recently been convincingly re-established as by Van Dyck on the basis of a related preparatory drawing and the free handling of the paint.14

Jordaens was appointed Dean of the Guild of Saint Luke in 1621 and forged a successful career as a hugely versatile artist, excelling in mythological and allegorical as well as religious subjects, and as a portrait painter (cats 6–12). Throughout his career he was a prolific and much sought-after designer for tapestries (cat.10).

Meanwhile, Rubens's wife had died in 1626 and he spent much of the following years travelling, most importantly on diplomatic missions to the Northern Netherlands, Spain (where he copied the famous collection of paintings by Titian; see cat.26) and England. Knighted by Charles I, he returned to Antwerp in 1630 and married Helena Fourment, thirty-seven years his junior, the same year. A period of relative domesticity and local stability followed, certainly by Rubens's standards; his children Clara Johanna and Frans were born in 1632 and 1633. But Rubens was as busy as ever, working on the paintings for the ceiling of the Banqueting House in Whitehall, commissioned by Charles I, on designs for a tapestry series of *The Life of Achilles*, and on the *Henry IV Series*, to complement the *Medici Series*. Van Dyck left for London in 1632, was knighted and became Charles I's principal court painter within a few months of his arrival. He settled permanently in Blackfriars and only once returned to the Netherlands, in 1634–5 (cat.5).

After the death of Archduchess Isabella in 1633, the Cardinal Infante Ferdinand of Austria was appointed Governor of the Southern Netherlands and held traditional 'Joyous Entries' in the major cities of the country (cats 23, 25). Rubens, at fifty-eight, was entrusted with yet another monumental project. Together with his friends Johannes Caspar Gervartius, a humanist scholar and clerk of the city, and Nicolaas Rockox, a city councillor and former mayor, he devised the programme for Ferdinand's triumphal entry into Antwerp. Rubens, moreover, provided the designs for the imagery and oversaw the production of the decorations, delivered in less than five months. For the huge canvases, Rubens recruited many of the leading painters of the day, among them Jan Boeckhorst, Jan Cossiers, Jacques (Jacob) Jordaens, Cornelis Schut, Theodoor van Thulden

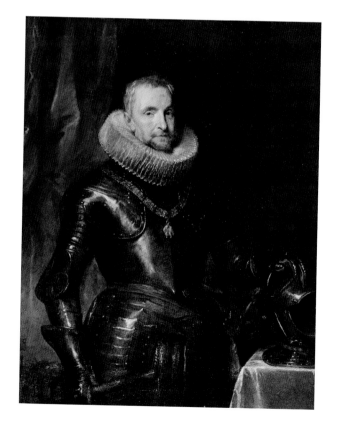

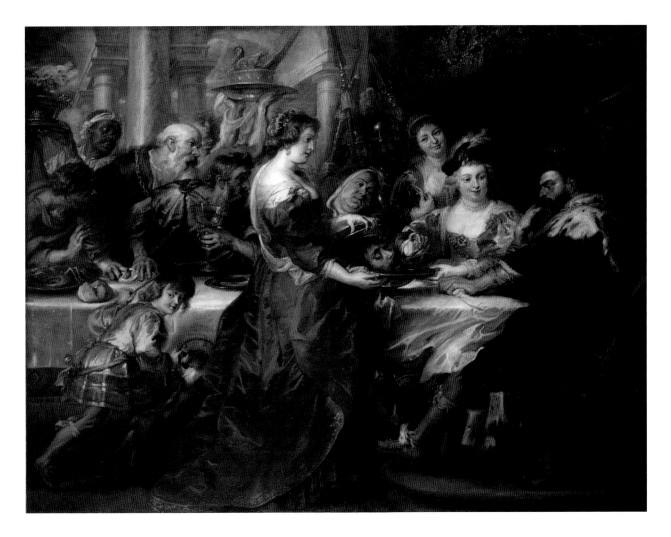

and Frans Wouters. Boeckhorst (1605–1668), from Münster (Westphalia), had settled in the city some years before and possibly trained with Jordaens, enrolling as a master in 1633.[15] Van Thulden (1606–1669) had recently returned from Paris where he had been since about 1631.[16] Born in 's-Hertogenbosch (Brabant), he had trained in Antwerp since 1621 and became a master in 1626. He contributed to the festivities of Ferdinand's entries into Ghent and Antwerp and was commissioned with the series of etchings after the latter (cat.25). A few years after this delayed project had been delivered, Van Thulden returned to 's-Hertogenbosch, which had been taken by the Dutch in 1629. Abraham van Diepenbeeck (1596–1675), also from the city of 's-Hertogenbosch, trained as a stained-glass painter and settled in Antwerp in 1622.[17] Although he occasionally produced paintings, he predominantly worked as a designer for stained

glass and, increasingly, prints (cat.3). Van Diepenbeeck was employed by Rubens in 1627 and again from 1636, designing title pages. Like Van Thulden, he spent some time in Paris in the early 1630s (cat.20). Wouters (1612–1659) had trained in Antwerp and briefly worked in Rubens's studio in 1634–5 before becoming an independent master (cat.26).[18] In 1635, Rubens purchased the estate of Het Steen, about twenty miles south of Antwerp, where he and his family gradually spent more time (cat.21).

The next commission came from Philip iv, again for a major series of paintings, to decorate his hunting lodge Torre de la Parada. Some artists who had worked for Rubens in 1635 were called upon again, among them Boeckhorst, Van Thulden and Jordaens. Around the same time, Rubens painted *The Feast of Herod* (fig.9).[19] Some figures, such as the bald man with the white beard

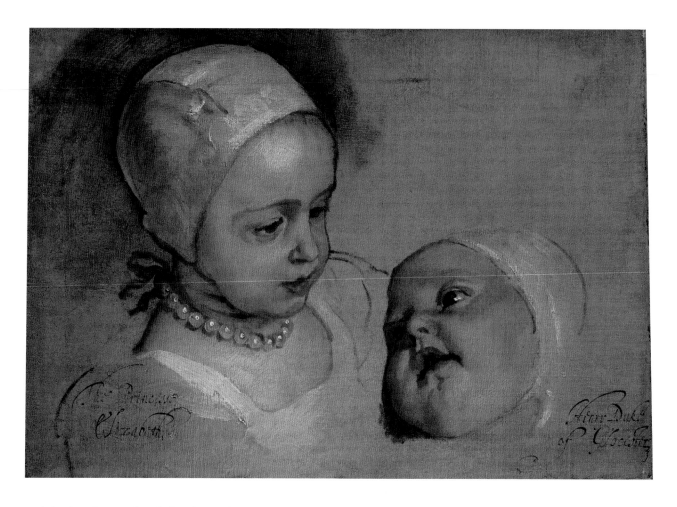

and the female attendant behind Herodias, are reminiscent of Jordaens's types and handling and may indeed have been painted by him. Meanwhile, Van Dyck had returned to London, his studio being busy with portraits for the king and his court. The charming oil sketch of the daughters of Charles I (fig.10) is a preparatory study for the group portrait *The Five Eldest Children of Charles I*.[20] The stately *Portrait of Charles Seton* (fig.11), a late work by Van Dyck, shows the sitter in his parliamentary robes – apparently the only occasion he was commissioned to paint a peer in his robes.[21]

AFTER THE DEATHS OF RUBENS AND VAN DYCK

Rubens and Van Dyck died within eighteen months of one another, in 1640 and 1641 respectively. Jordaens, at forty-eight, was suddenly the pre-eminent painter in the country. He completed two paintings left unfinished in Rubens's studio, intended for Philip IV, and was flooded with commissions from Flanders and beyond. He had

Fig.10 | Anthony van Dyck, *Princess Elizabeth (1635–1650) and Princess Anne (1637–1640)*, 1637, oil on canvas, 29.8 × 41.8 cm

Scottish National Portrait Gallery, Edinburgh, purchased with the aid of the Heritage Lottery Fund, the Scottish Office and the Art Fund 1996 (PG 3010)

acquired a large house in the city centre in 1639 and his workshop grew rapidly (cat.9). Balthasar Gerbier, Charles I's agent in Brussels, called him the greatest living painter in the Southern Netherlands. Most of his drawings in the exhibition are from those prolific years (cats 8–12). It was perhaps around 1650 that Jordaens converted to Protestantism.[22] The reasons are unknown, but his father-in-law, Adam van Noort, was a Protestant and the families were very close. Important commissions in the Northern Netherlands followed, first for the Oranjezaal in the Stadtholder's palace, Huis ten Bosch (1650–2), and then for the newly built Amsterdam Town

Fig.11 | Anthony van Dyck, *Portrait of Charles Seton,
2nd Earl of Dunfermline (1615–1672)*, *c*.1639–41,
oil on canvas, 220.7 × 134 cm
Scottish National Portrait Gallery, Edinburgh, purchased with assistance
from the Art Fund 1973 (PG 2222)

Hall, today the Royal Palace (1661, 1664). But Jordaens continued to paint altarpieces for Catholic churches in the south as well. Other artists who had worked with Rubens in the 1630s progressed their careers, such as Boeckhorst, Cossiers and Van Diepenbeeck (cats 1–3) and the impact of Rubens, Van Dyck and Jordaens on the younger generation of Flemish artists endured for decades and into the eighteenth century.

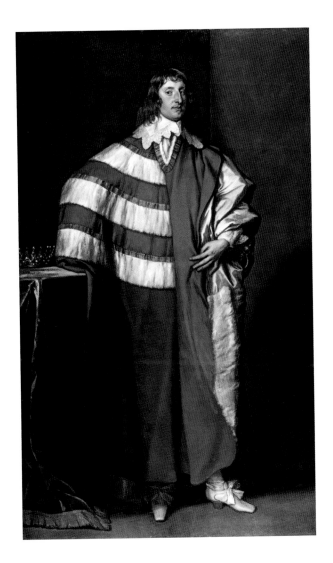

CATALOGUE NOTE

The catalogue is organised alphabetically by artist; their works are arranged in chronological order. The entries for cats 7, 10–12 were written by Victor Alers (VA).

NOTES & REFERENCES

1. Long known as Jacob Jordaens, the artist signed documents, even when written in Flemish, with his French first name 'Jacques'. It was only in the nineteenth century when Belgium became an independent state that Jordaens's first name was 'Flemishised', as has recently been shown; Brussels/Kassel 2012, pp.9–13.
2. For this introduction I gratefully acknowledge Belkin 1998 and Vlieghe 1998, both of which provide excellent further reading.
3. On Rubens's workshop see Vlieghe 1993 and Balis 2007.
4. Koninklijk Museum voor Schone Kunsten, Brussels, inv.4585; Brussels 2007, nos 39–40 (replica), ills. See also Vlieghe 1987, no.128.
5. On Jordaens's life and career see D'Hulst 1982, D'Hulst/ De Poorter 1993 and Münch/Pataki 2012.
6. On Van Dyck's early career see most recently Lammertse/ Vergara 2012.
7. Devisscher/Vlieghe 2014, no.13.
8. Kunsthistorisches Museum, Vienna, inv.524; McGrath 1997, no.55, fig.204; for the Gallery's study see ibid., p.304. For Van Dyck's copy (National Gallery, London, inv.50) see Barnes *et al.* 2004, no.I.87, fig.I.87; there the Vienna painting is attributed to Van Dyck, no.I.86. Lammertse/Vergara 2012, p.51 regard it as a collaborative work by both artists.
9. On Rubens's workshop practice see Balis 1993 and Brussels 2007.
10. Barnes *et al.* 2004, no.I.47.
11. D'Hulst/Vandenven 1989, no.16a.
12. Barnes *et al.* 2004, nos II.79, II.49.
13. On Cossiers, see Vlieghe 1996; on Schut, see Wilmers 1996.
14. Grosvenor 2014; Barnes *et al.* 2004, under no.III.A25 (as studio variant).
15. On Boeckhorst see Antwerp/Münster 1990 and Galen 2012.
16. On Van Thulden see 's-Hertogenbosch/Strasbourg 1991 and 's-Hertogenbosch 2000, pp.85–117 [P. Huys Janssen].
17. On Van Diepenbeeck see Steadman 1982 and 's-Hertogenbosch 2000, pp.53–83 [H. Vlieghe].
18. On Wouters see Hairs 1977, pp.48–52, Kemmer 1995 and Vlieghe 1998, p.111.
19. London 1982b, no.138.
20. Royal Collection, London, inv.404405; Barnes *et al.* 2004, nos IV.62, IV.63 (sketch), figs IV.62, IV.63.
21. Barnes *et al.* 2004, no.IV.102.
22. On Jordaens as a Protestant artist in Antwerp see Tümpel 1993.

1 · Jan Boeckhorst (1605–1668)
Noli me tangere, c.1660–2

Pen and brown ink, grey wash, 157 × 110 mm
(squared in black chalk)
Inscriptions: 'Maria, noli me tangere' (in grey ink); around the
tree (colour codes?) 'n'; 'ro'; 'sn'; 'ss' (in black ink)
Presented by the Earl of Crawford and Balcarres, 1970 (D 4968)

PROVENANCE: Prosper Henry Lankrink (1628–1692), London
[Lugt 2090]; Thomas Lawrence (1769–1830), London [Lugt
2445]; James Ludovic Lindsay, 26th Earl of Crawford and 9th
Earl of Balcarres (1847–1913), Balcarres; by descent to Robert
Alexander Lindsay, 29th Earl of Crawford and 12th Earl of
Balcarres (born 1927).[1]

REFERENCE: Ostrand 1975, p.138, no.A19; Lahrkamp 1982, p.57,
no.25a, ill.; Andrews 1985a, vol.1, p.9, vol.2, p.56, fig.56; Held
1985a, pp.16, 24, 31; De Vries 1991, p.264; Galen 2012, pp.324–6,
no.z56, fig.z56.

EXHIBITED: Edinburgh/London 1985;
Antwerp/Münster 1990, no.8.

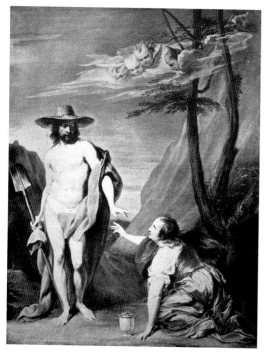

Fig.12 | Jan Boeckhorst, *Noli me Tangere*, 166[?],
oil on canvas, 138 × 106 cm
Present whereabouts unknown

According to the Gospel of Saint John, Mary Magdalene
went to Christ's sepulchre on Easter morning and
found it empty. On her way back, she encountered the
apostles Peter and John. Together they returned to the
grave but searched in vain for the body. After the apostles
had left, Mary stayed on to mourn. This is how Jesus
found her, Mary thinking he was the gardener. It was
only when Christ spoke her name that she recognised
him. Jesus then told her 'Touch me not!' (Latin *Noli me
tangere*), as he had not yet ascended into Heaven (John
20:14–18). Boeckhorst depicted precisely this moment,
the dramatic climax of the story: Mary reaches out to
convince herself of Christ's presence, but he tells her not
to touch him.

This is a preliminary drawing for a painting, the
present whereabouts of which is unknown (fig.12).[2]
With rapid, vigorous lines Boeckhorst sketched the
composition, focusing on the two figures. He reworked
the pose of Christ, most notably his head, initially shown
in profile. Boeckhorst indicated the tree to the right
and, very broadly, the background. Details such as the
angels' heads in the sky and Mary's alabastron, the small
vessel holding the anointing oil, were added at a later
stage. The squaring of the drawing indicates that it was
transferred, possibly for an oil sketch or directly onto the
canvas. The small letters around the tree in the drawing
may indicate colours.

1. An unidentified stamp lower left in green-blue ink.
2. Galen 2012, no.74, fig.74. She dates the painting, monogrammed and
dated 166[?] (the last figure is damaged), to 1660–2.

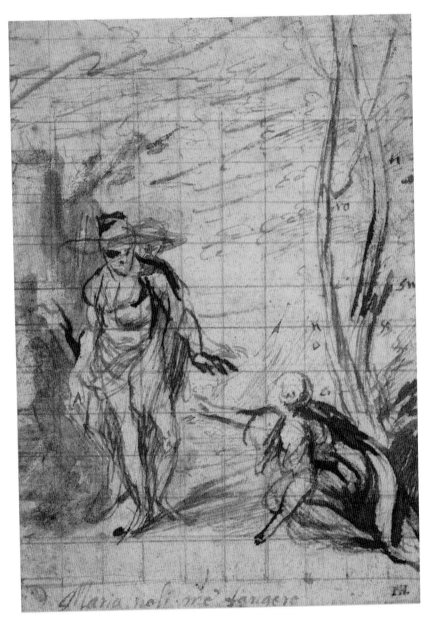

actual size

2 · Jan Cossiers (1600–1671)
*Head of a Man, c.*1655–60

Black, red and some white chalk, 281 × 182 mm (laid down)
Inscriptions top left: 'Cossiers' (in black chalk); on the mount
'Cossiers' (in brown ink) and on the verso of the mount: 'P Nº 84'
(in brown ink, partly erased)
David Laing Bequest to the Royal Scottish Academy 1878,
transferred to the Scottish National Gallery 1910 (D 1660)

PROVENANCE: Henry Temple, 2nd Viscount of Palmerston
(1739–1802) and/or his descendants, before 1878; David Laing
(1793–1878), Edinburgh.[1]

REFERENCE: Jaffé 1971, pp.47–9, note 34, fig.11; Andrews 1985a,
vol.1, p.19, vol.2, p.31, fig.127; Le Claire 1996, under no.7; S.
Alsteens in New York 2016, p.261, note 4, under no.99.

EXHIBITED: London 1953a, no.288; London 1953b, no.481;
London 1966, no.63; Edinburgh/London 1985; Edinburgh 1993;
Edinburgh 1999, no.33.

This drawing is closely related to a group of five portraits
depicting Cossiers's sons: Wilhelmus, Jacobus, Cornelis,
Jan Frans and Gerardus. All of these drawings are signed
and inscribed with the names of the sitters, the latter four
also being dated 1658.[2] They form the core of Cossiers's
small drawn oeuvre, consisting exclusively of portraits.

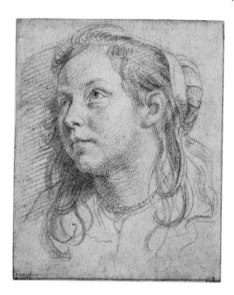

Fig.13 | Jan Cossiers, *Head of a Young Girl, c.*1658,
black, red and white chalk, 164 × 134 mm
Private collection, Germany

Head of a Man is a similar size to these portraits and
executed in the same technique. Fine cross-hatching in
red and black chalk defines the form of the face, with
some white heightening, combined with broad parallel
strokes surrounding the head. The portraits of the
artist's sons show slightly varying degrees of finish but
the Gallery's drawing is looser, particularly in the ren-
dering of the hair. The lower viewpoint is also different
from the group. Together with the view in profile and
his cast-down eyes this creates a distance between the
sitter and the viewer, and adds a monumental qual-
ity unique among Cossiers's portrait drawings. At the
same time, the man's costume, a long-sleeved(?) doublet
with standing collar – which supports a dating to about
1655–60 – adds a domestic intimacy. There can be little
doubt that this is a portrait. We know from documents
that Cossiers drew portraits of other members of his
family, now lost. Both the looser handling and the low
viewpoint also occur in the *Head of a Young Girl* (fig.13),
possibly one of Cossiers's daughters, although this is
smaller and more engaging than the present sheet.[3]

The inscription 'Cossiers' in the top left corner differs
from the signatures and inscriptions on the portraits of
his sons and is in black chalk (rather than brown ink). It
is certainly not a signature, although it confirms, as does
the artist's name on the mount, that this drawing has
been attributed to Cossiers in the past.

1. The mounting, including the inscriptions, is identical to the one of
Cossiers's *Portrait of the Artist's Son Guillielmus [Wilhelmus]* (Morgan Library &
Museum, New York, inv.1,248). The latter was owned by Henry Temple, 2nd
Viscount of Palmerston (1739–1802) and sold by his descendants in London
(Christie's), 24 April 1891, lot 129. As David Laing must have acquired the
Gallery's drawing before 1878, it seems likely that it had left the Palmerston
collection at an earlier date. With thanks to Ilona van Tuinen.
2. British Museum, London, inv.00,10.179; Rijksmuseum, Amsterdam,
inv.RP-T-2008–103 (formerly I.Q. van Regteren-Altena Collection; see
Schapelhouman/Scholten 2009, pp.106–9, no.11, ill.); Fondation Custodia
– Frits Lugt Collection, Paris, inv.1367; Lloyd Williams in Edinburgh 1999,
no.33 (with further literature). The present whereabouts of the fifth one
(Gerardus) is unknown; Baskett and Day 1987, no.35, ill.
3. Jaffé 1971, pp.47–9, fig.12; Le Claire 1996, no.7. Compare also the
broader execution of the *Head of a Young Child*, Le Claire 1998, no.12, ill.

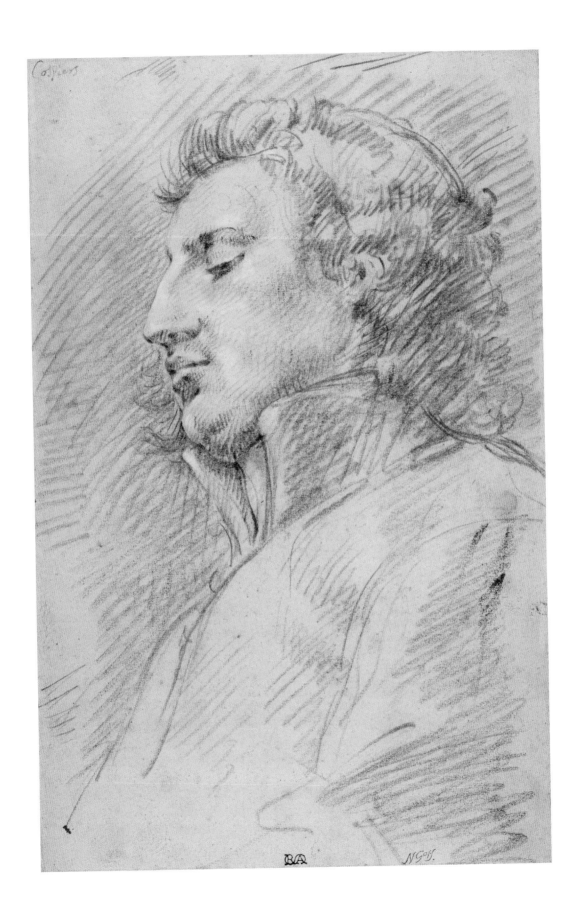

3 · Abraham van Diepenbeeck (1596–1675)
Saint Hyacinth of Cracow Crossing the River Dnieper, c.1635–55

Pen and brown ink over black chalk, black, grey and white watercolour and bodycolour, on grey paper (squared in black chalk), 357 × 399 mm
Inscriptions on verso: '6/25' (pen and black ink, top left); 'N° 2719.' (pen and red ink, lower left)
Watermark: large letters 'JR' surmounted by the number '4' (similar to Heawood 3066, Amsterdam 1617)[1]
David Laing Bequest to the Royal Scottish Academy 1878, transferred to the Scottish National Gallery 1910 (D 1741)

PROVENANCE: Valerius Röver (1686–1739), Delft [Lugt 2984b]; Johan Goll van Franckenstein Snr (1722–1785), Amsterdam [Lugt 2987]; David Laing (1793–1878), Edinburgh.

REFERENCE: Andrews 1985a, vol.1, p.21, vol.2, p.34, fig.140.

EXHIBITED: Edinburgh/London 1985.

1. See cat.5.
2. Severino 1594, pp.36–8. Andrews (p.21) suggested that the presence of the second friar was due to a conflation with the iconography of Saint Peter of Alcántara, a sixteenth-century Spanish Franciscan friar who walked over water with a companion. However, according to the official vita, Hyacinth escaped through the city gate together with his brothers and led them across the River Dnieper ('*illæsus vna cum fratribus portam exiuit. Et per Boristhenem fluuium substrata fratribus suis cappa sicci pedibus in alteram partem fluminis traiecit. proinde & se, & suos fratres à periculo liberauit.*'); Severino 1594, p.37.
3. In situ; photograph at the Netherlands Institute for Art History (RKD), The Hague (not online).
4. A pen and brush drawing attributed to Van Diepenbeeck probably shows a beardless Saint Hyacinth resurrecting a drowned man, conflated with the healing of a lame person and Saint Hyacinth's flight from Kiev (Ashmolean Museum, Oxford, inv.WA1941.138); Severino 1594, pp.32–3, 36–8.
5. Steadman 1982, pp.33–45, 69–81; Diels 2009.
6. '6/25; 2 *Monniken op Zee Wandelende met een Maria Beeld etc. gewass en veel gehooght van Dezelve*' (Diepenbeeke) *fl.5*'.
7. For these two collectors and their marks see Beck 1981.

Saint Hyacinth of Cracow was born in Silesia and educated in Prague and Bologna before he met Dominic, the founder of the eponymous order, in Rome in 1220. A first-generation Dominican, he became an important missionary in eastern Europe. Hyacinth died in 1257 and was buried in Cracow.

According to the legend, Hyacinth miraculously crossed the River Dnieper on foot during the Mongol siege of Kiev in 1240, saving the Holy Sacrament and an alabaster statue of Saint Mary as well as his fellow friars. The official life of Saint Hyacinth, published in 1594, the year Pope Clement VIII canonised him, gives a detailed account of this miracle.[2] There is little evidence for the veneration of Saint Hyacinth in the Netherlands. However, Theodor Boeijermans made a painting of him for the choir stalls of the church of Saint Andrew in Antwerp[3] and it seems likely that Van Diepenbeeck also received a commission for this rare subject.[4]

His drawing is a refined compositional design, which he amended in the process, as demonstrated, for example, by the putto with the bell and the accompanying friar, both of whom were first outlined in black chalk in different poses. The squaring of the sheet indicates that it was prepared for transfer. A grisaille executed in various shades of grey, it may have been a design for a print, although none has been identified so far. Van Diepenbeeck was involved in printmaking from the 1630s but particularly towards the end of his career.[5]

Van Diepenbeeck's drawing was in the famous eighteenth-century collection of Valerius Röver of Delft, who habitually inscribed his numbers on the reverse. In his manuscript catalogue, today in the Library of the University of Amsterdam, he specified the present drawing as sheet twenty-five in portfolio six and attributed it to Van Diepenbeeck; the knowledge of its rare subject had been lost.[6] Röver's collection ultimately passed to the Amsterdam collector Johan Goll van Franckenstein Snr, who inscribed his number on the reverse as well.[7]

4 · Anthony van Dyck (1599–1641)
Study for the Portrait of Nicholas Lanier (1588–1666), 1628

Black chalk, heightened with white, on blue paper, 394 × 285 mm
Lady Murray of Henderland Gift 1860 as a memorial to her
husband, Lord Murray of Henderland (D 1846)

PROVENANCE: Prosper Henry Lankrink (1628–1692), London
[Lugt 2090]; Joseph van Aken (c.1699–1749), London [Lugt
2516]; probably Allan Ramsay Jnr (1713–1784), Edinburgh/
London; probably his son, John Ramsay (1768–1845), London;
probably William Murray of Henderland (D.1854), London;
his brother, John Archibald, Lord Murray of Henderland
(1778?–1859), Edinburgh; his wife, Lady Murray of Henderland
(D.1861), Edinburgh.[1]

REFERENCE: NGS 1912, p.289; Stuart Wortley 1937, pp.26–8,
pl.27; White 1960, p.514; Andrews 1961, no.31, ill.; Vey 1962,
vol.1, pp.275–6, no.203, vol.2, fig.251; Andrews 1985a, vol.1,
p.24, vol.2, p.38, fig.159; Larsen 1988, vol.1, p.333, fig.351, vol.2,
under no.898; Washington 1990, pp.207–8, under no.48, fig.1;
Wilson 1994, pp.108–9, note 30, pl.17; Barnes et al. 2004, p.321,
under no.III.92; London 2010, pp.30–1, fig.13; Díaz Padrón
2012, vol.2, p.576, under no.79, fig.79.1.

EXHIBITED: London 1938, no.603; Rotterdam 1948, no.90;
Brussels/Paris 1949, no.126; Leicester 1952, no.28; Antwerp/
Rotterdam 1960, no.94; Edinburgh 1963, no.45; London
1966, no.52; London 1972a, no.112; London 1982a, no.67;
Washington/Fort Worth 1990, no.71; Edinburgh 1993; Tel Aviv
1995, no.15; Edinburgh 2007; London 2009, no.78; New York
2016, no.20.

This is a preparatory study for Van Dyck's *Portrait of
Nicholas Lanier* (fig.14). The identity of the sitter is
confirmed by comparison with an inscribed engraving
by Lucas Vorsterman after a portrait by Jan Lievens of
the same sitter.[2] Lanier was a successful singer, musi-
cian and composer, and Master of the King's Music
to Charles I and, after fifteen years in exile during the
English Civil War, to Charles II. An accomplished
painter himself, Lanier assembled one of the first impor-
tant collections of drawings in Britain.[3]

This swift drawing focuses on the sitter's costume,
his features sparsely indicated with soft lines. This
corresponds with Van Dyck's practice as described by
the French artist and writer Roger de Piles in 1708: the
painter would sketch the head in oil on canvas and then
'put the sitter into some attitude he had before contrived;

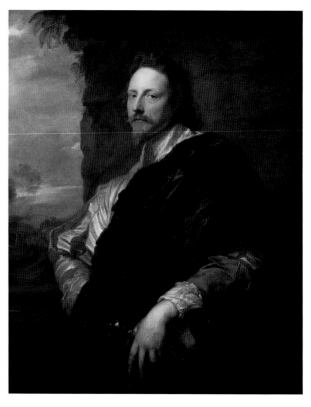

Fig.14 | Anthony van Dyck, *Portrait of Nicholas Lanier*, 1628,
oil on canvas, 111 × 87.6 cm
Kunsthistorisches Museum, Vienna (GG 501)

and on grey paper, with white and black crayons, he
designed, in a quarter of an hour, his shape and dra-
pery'.[4] Peter Lely, who succeeded Van Dyck as the most
fashionable portraitist in London, related in 1672 that
Lanier's portrait was painted in seven consecutive days.
Its date has been a matter of debate, but most likely
Lanier sat to Van Dyck in Antwerp in 1628.[5]

This is one of the earliest studies by Van Dyck in
black and white chalk on blue paper, a technique he had
encountered in Venice during his Italian sojourn (1621–
7). Blue paper is characteristic of Van Dyck's studies in
his later career; neither Rubens nor other Flemish por-
trait painters seem to have used it.[6] The most significant

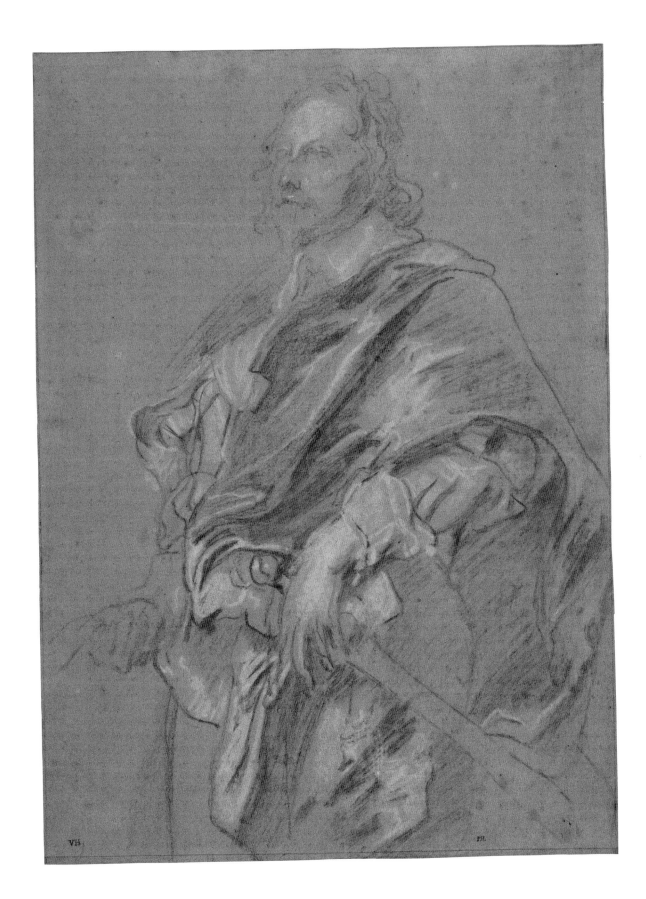

VB. PIL.

difference between the drawing and the painting is the position of Lanier's right hand. First indicated stretched out and holding a glove, Van Dyck abandoned this pose in the drawing and changed Lanier's right contour accordingly, only to remove this part of Lanier's cloak again in the painting.

1. On the provenance of two albums of drawings from Allan Ramsay's estate see Smailes in New York 2014, p.51. The *Study for the Portrait of Nicolas Lanier* took pride of place as the first item in volume one: 'Drawings by Ancient Masters & from the Living Models and Statues'; *National Gallery of Scotland: [Manuscript] Catalogue of Drawings & Prints, January 1912*, s.p. (in curatorial department). The albums were dismantled and discarded at an unknown date between 1914 and 1919; compare NGS 1914, p.294 (with reference to 'vol.1, 1') and NGS 1919, p.303 (with reference to 'R.N. 1846').
2. Barnes *et al.* 2004, no.III.92. For the print see Hollstein, vol.43 (1993), p.171, no.168, ill. [C. Schuckman].
3. For Lanier see Wilson 1994, for his collection Wood 2003.
4. De Piles 1743, p.177; Alsteens 2016, p.18.
5. For the Lely anecdote and date see Eaker in New York 2016, no.20.
6. Alsteens 2016, p.19.

Fig.15 | Anthony van Dyck, *Portrait of Henrietta of Lorraine*, 1634, oil on canvas, 213.4 × 127 cm
Kenwood House, London (47)

5 · Anthony van Dyck (1599–1641)
Study for the Portrait of Henrietta of Lorraine (1611–1660), 1634

Black chalk, traces of white chalk, on light grey (probably formerly blue) paper, 529 × 302 mm (arched top)
Watermark: large letters 'JR' surmounted by the number '4' (similar to Heawood 3066, Amsterdam 1617)[1]
David Laing Bequest to the Royal Scottish Academy 1878, transferred to the Scottish National Gallery 1910 (D 1738)

PROVENANCE: Thomas Hudson (1701–1779), London [Lugt 2432]; Joshua Reynolds (1723–1792), London [Lugt 2364]; David Laing (1793–1878), Edinburgh.

REFERENCE: NGS 1912, p.289; Vey 1962, vol.1, pp.265–6, no.195, vol.2, fig.234; Andrews 1985a, vol.1, p.24, vol.2, p.38, fig.158; Bryant 2003, pp.46–7, fig.3; Barnes *et al.* 2004, p.330, under no.III.102.

EXHIBITED: Antwerp 1949, no.104; Antwerp/Rotterdam 1960, no.107; Plymouth 2009, no.66; New York 2016, no.23.

This strikingly large drawing is a preparatory study for the full-length *Portrait of Henrietta of Lorraine*, dated 1634 (fig.15).[2] The identity of the sitter is confirmed by a contemporary inscription on the painting as well as by an engraving by Cornelis Galle the Younger after a similar portrait by Van Dyck.[3] Henrietta and her sister Marguerite fled when French troops approached Nancy and took refuge in Brussels. There they joined Marguerite's husband Gaston, Duc d'Orléans, the younger brother of the French King Louis XIII, and his mother, Maria de' Medici. With Spanish support, Gaston raised troops against his brother, but failed to oust him.

Executed during Van Dyck's brief stint at Brussels in 1634–5, this drawing is far more reduced than the *Study for the Portrait of Nicholas Lanier* (cat.4). It merely outlines the composition of the painting, focusing on the pose of the sitter, a summary of the costume – clearly showing the Flemish wired bobbin-lace collar and cuffs – and the position of the hands. Henrietta's head and features are indicated by just a few lines. This study, perhaps even more than the *Study for the Portrait of Nicholas Lanier*, seems to be the work of 'a quarter of an hour', as described by the French artist and writer Roger de Piles (see cat.4).

1. Stijn Alsteens kindly informed me that the same watermark can be found in several drawings from this period; New York 2016, nos 25, 28–30.
2. Barnes *et al.* 2004, p.329, no.III.102.
3. Turner 2002, vol.3, no.146, ill.

6 · Jacques (Jacob) Jordaens (1593–1678)
Head of an Old Woman, with a Ruff and a Cap, c.1625–40

Black and white chalk, 301 × 195 mm
Inscriptions recto: 'n ab' (lower right, in brown ink); verso: 'Jordaans' (top left, in brown ink); unidentified paraph 'B[…]' (centre, in brown ink); 'Goltzius/ Sir T Lawrence Coll/ 10 [?]' (lower right, in pencil)
Watermark: five-petalled flower on stem ending in a 'v'.[1]
David Laing Bequest to the Royal Scottish Academy 1878, transferred to the Scottish National Gallery 1910 (D 1683)

PROVENANCE: Thomas Lawrence (1769–1830), London [Lugt 2445]; David Laing (1793–1878), Edinburgh.

REFERENCE: NGS 1912, p.289 (as Dutch School); Haverkamp-Begemann 1969, p.176 (as Dutch, style of Leendert van der Cooghen); Held 1969, pp.268–9, fig.2 (as unknown artist); D'Hulst 1969, p.386, no.153 (as strongly reminiscent of the School of Haarlem); D'Hulst 1974, vol.2, pp.587–8, no.D39, vol.4, fig.629a (as strongly reminiscent of the Haarlem School); Andrews 1985a, vol.1, p.42, vol.2, p.70, fig.284; Held 1985b, p.49, pl.26 (as Jacob van Campen); Q. Buvelot in Amsterdam 1995, p.252, note 66 (as not by Van Campen).

EXHIBITED: Ottawa 1968, no.153; Edinburgh/London 1985; Washington/Fort Worth 1990, no.65; Edinburgh 1993; Edinburgh 2013, pp.12–13.

This drawing belongs to a group of four (figs 17–20), executed in black chalk (one in black and red chalk) and heightened with white chalk, and depicting the same woman. They all focus on her head, albeit at different angles and in varying poses, creating an air of intimacy and spontaneity.

The identity of the woman and the attribution of this group of drawings have been debated in the past. According to an inscription on the verso associated with Hendrick Goltzius, the present drawing entered the collection as 'Dutch School'. Michael Jaffé attributed it to Jordaens and identified the sitter as the painter's mother-in-law, Elisabeth van Noort. Both Jaffé's attribution and identification have been challenged; alternative

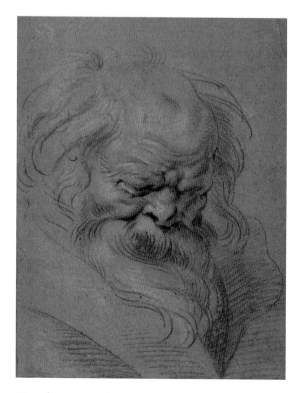

Fig.16 | Jacques Jordaens, *Head of an Old Man*, c.1640, black and white chalk, 341 × 261 mm
Albertina, Vienna (8276)

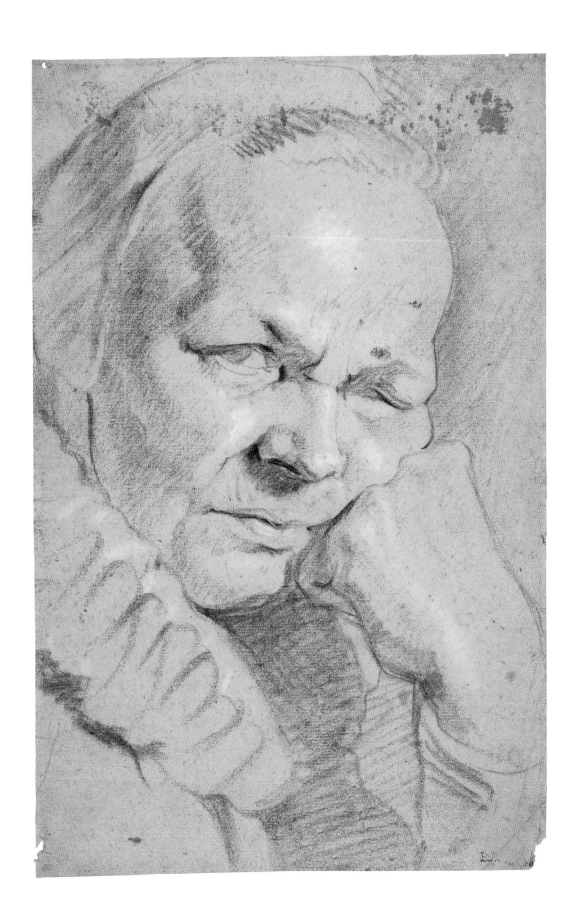

Fig.17 | Jacques Jordaens, *Head of an Old Woman* (recto),
c.1625–40, brush and brown ink, 189 × 181 mm
Nationalmuseum, Stockholm (2185/1863)

Fig.18 | Jacques Jordaens, *Head of an Old Woman* (verso),
c.1625–40, black and white chalk, 189 × 181 mm
Nationalmuseum, Stockholm (2185/1863)

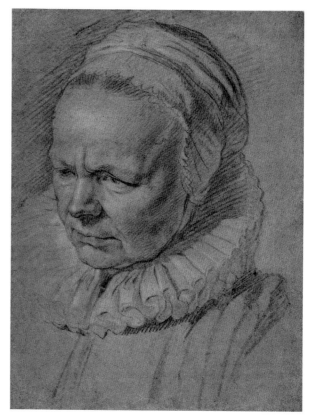

Fig.19 | Jacques Jordaens, *Head of an Old Woman*,
c.1625–40, black and white chalk, 292 × 193 mm
Peck Collection, Boston (P10.01)

Fig.20 | Jacques Jordaens, *Head of an Old Woman*,
c.1625–40, black, red and white chalk, 326 × 246 mm
Peck Collection, Boston (P00.03)

suggestions for the artist include the draughtsman Leendert van der Cooghen, and the architect and painter Jacob van Campen.

For head studies, Jordaens routinely used red and black chalk, often heightened with white chalk. However, occasionally he employed only black and white chalks, as in the *Head of an Old Man* of about 1640 (fig.16).[2] With its broad and vigorous handling, the dark accents around the eyes and nostrils and the hatching, it compares well to the Gallery's drawing and supports the attribution to Jordaens.

Whether the woman is indeed Elisabeth van Noort is more difficult to decide. Her birth and death dates are unknown. She married Adam van Noort in 1586, when he was twenty-four years old, and had five children between 1587 and 1598. Jaffé compared the drawings with her likeness in the family portrait of about 1615–6 (fig.21), when she was at least in her late forties, if not older. Some of Elisabeth's features are similar to the woman in the drawings, such as the shape of the eyes and the slight squint as well as the position of her mouth and the folds coming down from her nose. Elisabeth's nose, however, is longer and grows straight out from her forehead. The nose of the woman in the drawings is shorter, hits the forehead at an angle, and is marked by a distinct fold. While the former features may alter over time – and the drawings perhaps date from about 1625 to 1640 – the latter will remain relatively unchanged; compare, for example, Jordaens's own features and those of his wife in the existing portraits.[3]

Fig.21 | Jacques Jordaens, *Portrait of the Families Jordaens and Van Noort* (detail), *c.*1615–16, oil on canvas, 114 × 164.5 cm
Gemäldegalerie Alte Meister, Museumslandschaft Hessen Kassel, Kassel (GK 107)

1. Apparently the same watermark as in fig.19 (kind communication from Sheldon Peck).
2. D'Hulst 1974, no.A133. The recto of the drawing in Stockholm shows the same woman again, but is executed in brush and brown ink (fig.17). This is an unusual technique for Jordaens; but compare D'Hulst 1974, no.A23, fig.23 and no.A54, fig.61.
3. D'Hulst 1982, figs 232–4; Nelson 1989.

7 · Jacques (Jacob) Jordaens (1593–1678)
The Adoration of the Shepherds, c.1630–40

Watercolour and bodycolour, 187 × 260 mm
David Laing Bequest to the Royal Scottish Academy 1878,
on loan to the Scottish National Gallery 1966 (RSA 22)

PROVENANCE: David Laing (1793–1878), Edinburgh.

REFERENCE: Jaffé 1966a, pp.628–9, fig.46; D'Hulst 1974, vol.1,
p.194, no.A95, vol.3, fig.105; Andrews 1985a, vol.1, p.42, vol.2,
p.71, fig.285.

EXHIBITED: Antwerp/Rotterdam 1966, no.45;
Edinburgh 1976, no.37.

Mary and the Christ Child, with Joseph, the ox and the ass beside them, are adored by the shepherds on the right, as described in the Gospel of Saint Luke (2:8–20). Throughout his career, Jordaens made a number of drawings and paintings of this subject, perhaps because it allowed him to portray a sacred event in everyday surroundings. By emphasising the ass, who is depicted in the centre of the composition, and the ox, whose head is visually separated from its body by the wooden post of the stable, Jordaens diverted attention away from Mary, the child and the adoration. He has instead focused on the pictorial elements and the interaction of different colours. Since several motifs, such as the ox behind the pole, were taken from other sketches, it was necessary to make an elaborate preparatory drawing in order to achieve visual coherence.

D'Hulst pointed out that the composition and execution of *The Adoration of the Shepherds* are similar to a drawing in the Albertina in Vienna, and dated both works to about 1630–5.[1] This dating is, however, not firmly grounded: it is based on a group of similar drawings by Jordaens that cannot be dated securely either. Therefore, a broader dating to about 1630–40 seems more appropriate.

For this sketch, Jordaens added a strip to the main sheet before he started drawing. Both the strip and the sheet are likely to have been re-used as they show faint sketches in black chalk on the reverse that do not relate to one another.[2] VA

1. Inv.44.264; D'Hulst 1974, no.A94, fig.104.
2. For Jordaens's re-use of sheets see D'Hulst 1974, p.59.

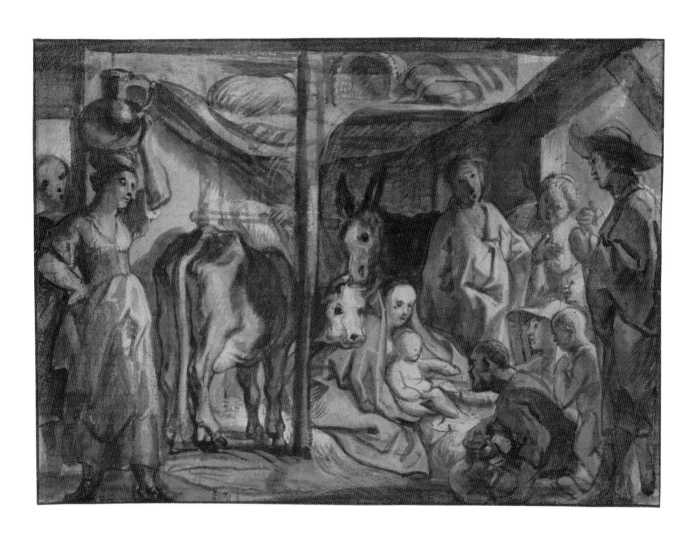

8 · Jacques (Jacob) Jordaens (1593–1678)
*Diana and Callisto, c.*1640

Pen and black ink over black chalk, brown, ochre and grey watercolour, white bodycolour, incised, 102 mm (diameter, laid down, frame line in black ink added)
Purchased 2000 (D 5505)

PROVENANCE: Walter von Wenz (1898–1963), Eindhoven (1956, 1957); sale Amsterdam (Sotheby Mak van Waay), 18 November 1980, lot 90; Adolphe Stein (1913–2002), London (1981); Ian Woodner (1903–1990), New York; his sale, London (Christie's), 2 July 1991, lot 199; Jiles Boon (1916–2009), Rotterdam [Lugt 3355]; Bob Haboldt, Paris & New York; purchased from Robert Noortman (1946–2007), Maastricht, 2000.

REFERENCE: D'Hulst 1957, pp.146–7, fig.8; D'Hulst 1974, vol.1, pp.328–9, no.A254, vol.3, fig.270; D'Hulst 1982, pp.182, 351, fig.151; M. de Haan in Rotterdam 2001, p.164, under no.38, fig.2.

EXHIBITED: Brookville 1986, pp.26–7; Edinburgh 2001, no.19.

The mythological story of Diana and Callisto, related by the ancient Roman poet Ovid in the *Metamorphoses* (11: 401–507), was a popular subject in art, as it offered the opportunity to show female nudes in a variety of poses. Diana, the chaste goddess of hunting, seated on the left, discovers that Callisto, one of her nymphs, is pregnant by Jupiter and banishes her from her company. After Callisto gave birth to a son, Jupiter's enraged wife Juno transformed her into a bear, but the 'Father of the Gods' set her among the stars, where she forms the constellation known as the Great Bear.

The drawing derives from a larger, rectangular one by Jordaens of the same subject (fig.22).[1] The group of Callisto and the three nymphs is virtually the same in both drawings, although the companion behind her is only outlined in black chalk on the sheet in Rotterdam. Around the figures on the latter, Jordaens drew two thin circles in black chalk, the diameter of the inner exactly corresponding with the drawing in Edinburgh. Jordaens apparently 'tested' whether the composition was suitable for this shape. Indeed, he introduced only a few changes in the present drawing, adding a tree behind the figures and adapting the poses of the nymphs around Diana.

The Rotterdam drawing is a sketch for a painting of about 1640 in the Real Academia de Bellas Artes de San

Fig.22 | Jacques Jordaens, *Diana and Callisto, c.*1640, pen and brown ink over black chalk, grey, red and brown watercolour, 160 × 240 mm
Museum Boijmans Van Beuningen, Rotterdam (MB 5010)

Fernando, Madrid.[2] This suggests that the Gallery's drawing dates from about the same period. The shape and dimensions as well as the contrasting light and shade evoke a relief. Perhaps Jordaens provided a design for an ivory carving, as Rubens occasionally did. Given the rarity of profane subjects in Netherlandish glass roundels of the seventeenth century and their average diameter being considerably larger, it seems unlikely that Jordaens's design was made in preparation for such a roundel.[3]

1. Rotterdam 2001, no.38.
2. Inv.I.427; González de Amezua *et al.* 2004, pp.86–7, ill.
3. Cole 1993, pp.xx–xxi. Cole gives the average standard diameter as 22 cm. Of the 2,554 objects he catalogued, only eight have subjects from classical mythology or history; Diana does not feature at all.

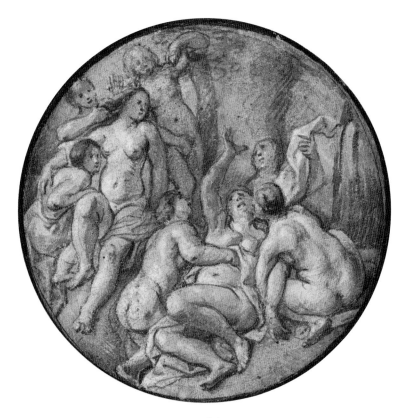

actual size

9 · Jacques (Jacob) Jordaens (1593–1678)
Female Nude, c.1641

Black, red and white chalk, 258 × 213 mm
Inscribed recto: 'J. Jordaens.' (in brown ink, lower left); '20'
(pencil, lower centre)
David Laing Bequest to the Royal Scottish Academy 1878,
transferred to the Scottish National Gallery 1910 (D 1696)

PROVENANCE: David Laing (1793–1878), Edinburgh.

REFERENCE: NGS 1912, p.291; Moussalli 1956, p.667; D'Hulst
1956, p.413, no.228 (as an eighteenth-century copy); Held 1969,
p.267; D'Hulst 1969, pp.383, 386; D'Hulst 1974, vol.1, p.245,
no.A152, vol.3, fig.164; Andrews 1985a, vol.1, pp.41–2, vol.2,
p.70, fig.283.

EXHIBITED: London 1927, no.613; London 1938, no.587;
Brussels/Paris 1949, no.139; Ottawa 1968, no.194; Edinburgh
1993; Antwerp 1993, vol.2, no.B47; Edinburgh 1999, no.30;
Brussels/Kassel 2012, no.103; Sydney 2015, no.56.

This is a study for one of a series of twelve paintings of
The Signs of the Zodiac that Jordaens made for the ceilings
of his own house in Antwerp around 1641.[1] Probably
sold before 1764, they surfaced at auction in Paris in
1802 and were acquired by the French state. Since
1803, the series has decorated the Senate Library in the
Palais du Luxembourg, Paris. This drawing is a study for
the principal figure in the painting *Capricorn: Adrastea
Milking the Goat Amalthea*, a subject from Greek mythol-
ogy (fig.23). Together with her sister Ida, the nymph
Adrastea looked after the infant Jupiter. The young
god, soon to become the 'Father of the Gods', had to be

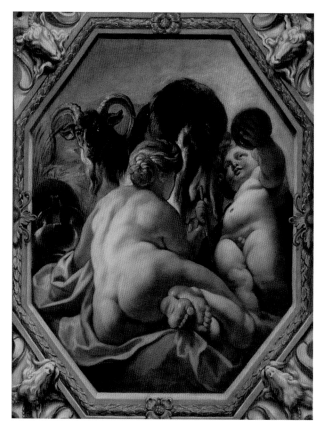

Fig.23 | Jacques Jordaens, *Capricorn: Adrastea Milking the Goat
Amalthea*, c.1641, oil on canvas, about 200 × 145 cm
Senate Library, Palais du Luxembourg, Paris

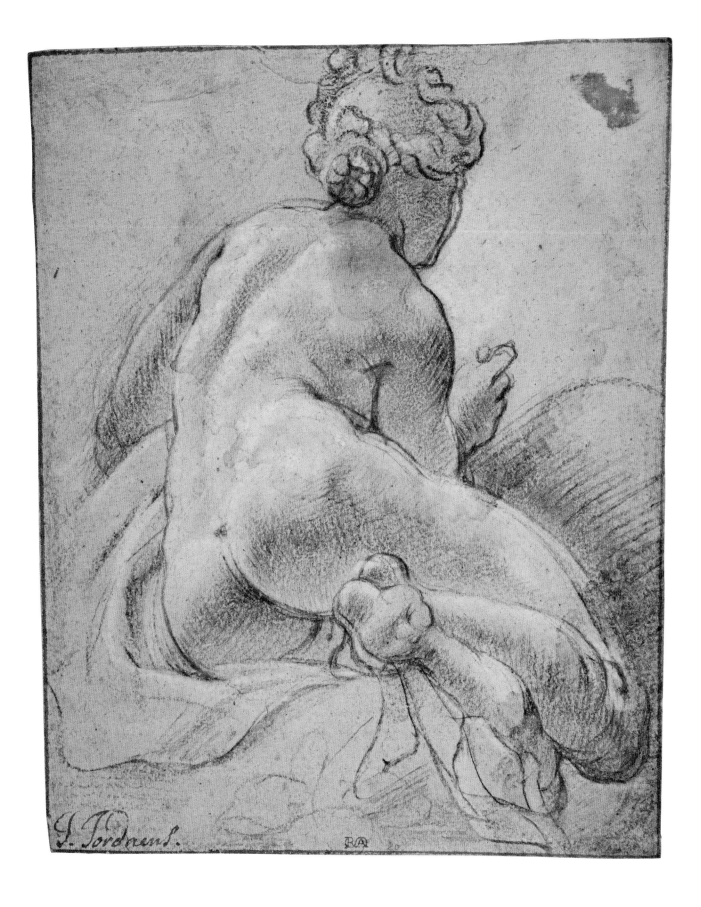

J. Jordaens.

hidden from his own father, Saturn, who devoured all his children at birth. The nymphs fed Jupiter with milk from the goat (Apollodorus, *Biblioteca*, 1:1.5–7).

Drawn *aux trois crayons*, in red, black and white chalks, this drawing was once regarded as a partial copy after the painting and thought to have been made in eighteenth-century France, where this technique was particularly popular. However, Jordaens frequently made studies in three chalks, perhaps inspired by Rubens. The reverse of this drawing shows another female nude, executed only in black chalk, which relates to the central figure in the sign of *Gemini: Venus, Castor and Pollux* from the same series of paintings (figs 24, 25). The *Female Nude* was

initially such a black chalk study, too, which Jordaens subsequently worked up in red chalk and heightened with a little white to great aesthetic effect. However, he used the red chalk mainly to correct certain contours of the figure, with these lines being closer to the finished painting. It is these changes in particular that, together with differences between the drawing and the painting and taken with the sketch on the verso, prove beyond doubt that this drawing is not a copy after Jordaens's painting. A similar use of red chalk can be found in a figure study of *Two Crouching Nudes*, which is a preparatory drawing for Jordaens's painting *Susanna and the Elders* of about 1640–5 (Museo di Castelvecchio, Verona).[2]

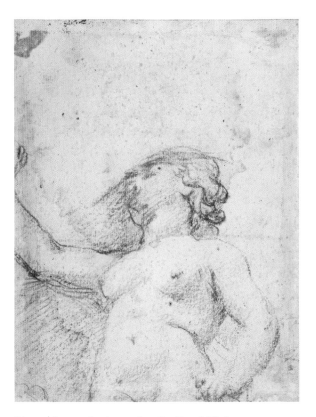

Fig. 24 | Jacques Jordaens, *Standing Female Nude* (verso of cat. 9), *c.*1641, black chalk
Scottish National Gallery, Edinburgh

Fig. 25 | Jacques Jordaens, *Gemini: Venus, Castor and Pollux*, *c.*1641, oil on canvas, about 145 × 200 cm
Senate Library, Palais du Luxembourg, Paris

1. Tijs 1983, pp. 261–354, ill. on p. 322.
2. National Gallery of Art, Washington, inv. B.7643; Antwerp 1993, no. B50, ill., fig. B50a (painting).

10 · Jacques (Jacob) Jordaens (1593–1678)
As the Old Sing, so the Young Pipe, c.1644

Pen and brush and brown ink, watercolour and bodycolour over black chalk, 262 × 298 mm (laid down)
Inscription on verso: 'voor 5 satijn [or: Parijse [ponden]] 7 ellen min den boort 5½ binnen' (in black chalk)[1]
David Laing Bequest to the Royal Scottish Academy 1878, transferred to the Scottish National Gallery 1910 (D 1192)

PROVENANCE: Benjamin West (1738–1820), London [Lugt 419]; David Laing (1793–1878), Edinburgh.

REFERENCE: NGS 1912, p.291; Dodgson 1913, no.23; Van Puyvelde 1953, pp.176, 205, fig.96; D'Hulst 1956, pp.230–1, 233, 361–2, no.100, fig.150; D'Hulst 1974, vol.1, pp.275–6, no.A188, vol.3, fig.202; D'Hulst 1982, p.301; Andrews 1985a, vol.1, p.41, vol.2, p.69, fig.281; Nelson 1985, p.224, pl.35; Antwerp 1993, vol.1, p.204, fig.A64a; Nelson 1998, pp.104, 277, no.26a, pl.59; Rutgers 2012, p.302, note 35.

EXHIBITED: London 1927, no.620; Brussels 1965, no.334; Antwerp/Rotterdam 1966, no.75; Ottawa 1968, no.216; Edinburgh 1993; Edinburgh 1999, no.31; Edinburgh 2013, pp.14–15.

Three generations have gathered around a table for a merry meal. The scene illustrates the proverb 'As the old sing, so the young pipe', which was popularised by the Calvinist poet Jacob Cats in his *Mirror of the Old and the New Ages* from 1632.[2] The expression emphasises that the young imitate the old, implicitly encouraging the parents to set a good example for their offspring. Jordaens represented the proverb quite literally by depicting an elderly couple singing and two young children playing flutes, all accompanied by a woman and a bagpiper.

The drawing is a preparatory study for a tapestry. On 22 September 1644 Jordaens signed a contract with the Brussels weavers Frans van Cophem, Jan Cordys and Boudewyn van Beveren, in which he agreed to deliver the designs for a series of eight tapestries, all related to 'certain proverbs which will be chosen as appropriate by Mr. Jordaens'.[3] In this drawing, Jordaens elaborated on his earlier compositions of the same subject, such as the painting of 1638 in the Koninklijk Museum voor Schone Kunsten, Antwerp.[4] He adapted the composition for a tapestry, depicting the figures full-length and enlarging the room.

Jordaens was one of the most prolific designers of tapestries in his time. He usually started with a preparatory drawing executed in chalk, watercolour and bodycolour, such as the present work. The design of the drawing was then transferred to an oil sketch, which for *As the Old Sing, so the Young Pipe* is now in a private collection in France.[5] Finally, the weavers turned the oil sketch into a full-scale cartoon on heavy paper, which would guide them in the weaving. The inscription on the reverse of the present drawing certainly refers to the production of the tapestry although the exact meaning remains elusive. At least three sets of the eight proverb tapestries were woven. Two sets were purchased by Archduke Leopold William in 1647, one of which is now in Castle Hluboká, Czech Republic, the other being lost.[6] Jordaens's light-hearted illustrations of the proverbs were popular among the Flemish elite for their literal and straightforward depiction of everyday life. VA

1. With many thanks to Marten Jan Bok and Harm Nijboer (who read 'satijn') and Koen Brosens (who reads 'Parijse [ponden]').
2. '*Siet alderhande jongen / Die pijpen even soo gelijck de moeders songen*', Cats 1632, p.65.
3. Nelson 1998, pp.33, 192, appendix III.
4. Inv.677; Antwerp 1993, vol.1, no.A55, ill.
5. Nelson 1998, no.26b, fig.60.
6. Nelson 1998, pp.33–6.

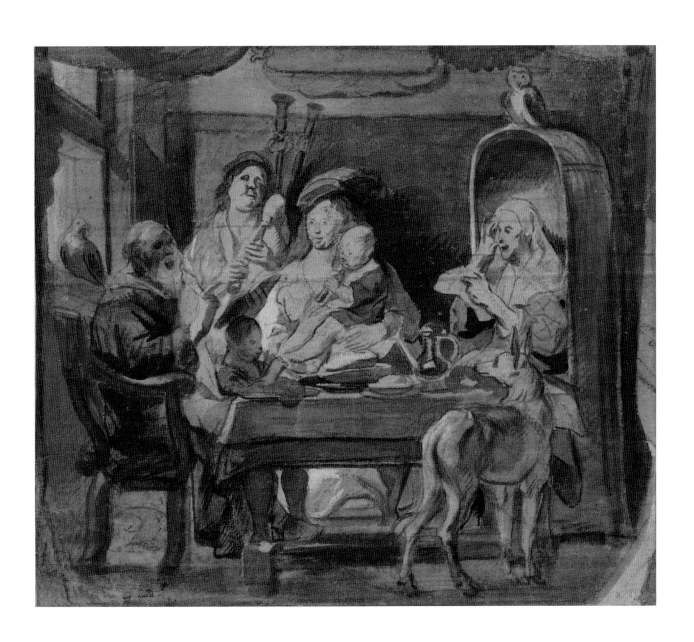

11 · Jacques (Jacob) Jordaens (1593–1678)
The Adoration of the Magi, c.1640–50

Watercolour and bodycolour over black chalk,
475 × 350 mm (laid down)
Inscription lower right: 'J. Jordaens' (in black ink)
Inscriptions on verso: '(Old Masters)/ Original drawing of the
Adoration of the Magi by Jordaens/ From the Collection of
Thomas Lawrence and his Stamp "T.L."/ Also on back the Stamp
"B" Collection of – / Jacob Jordaens born at Antwerp 1594 died
there 1678.' (in black ink); '£12–2–0' (in red chalk)
William Findlay Watson Bequest 1881 (D 2262)

PROVENANCE: Thomas Dimsdale (1758–1823), London [Lugt
2426]; Thomas Lawrence (1769–1830), London [Lugt 2445];
William Findlay Watson (1810–1881), Edinburgh.

REFERENCE: NGS 1912, p.291; D'Hulst 1956, pp.226, 228, 359,
no.95, fig.147; Andrews 1961, no.30, ill.; D'Hulst 1974, vol.1,
pp.272–3, no.A186, vol.3, fig.200; Andrews 1985a, vol.1, p.41,
vol.2, p.69, fig.280; R.-A. d'Hulst in Antwerp 1993, vol.1, p.216,
under no.A68.

EXHIBITED: London 1927, no.618; London 1938, no.570;
London 1953a, no.261; London 1953b, no.528; Antwerp 1954,
no.316; London 1966, no.58; Antwerp/Rotterdam 1966, no.73;
Ottawa 1968, no.221; Edinburgh 1981, no.16; Edinburgh/
London 1985; Washington/Fort Worth 1990, no.66; Edinburgh
1993.

The three kings, Caspar, Melchior and Balthazar,
worship the new-born Christ Child, sitting on Mary's
lap on the right, surrounded by onlookers, as described
in the Gospel of Saint Matthew (2:1–12). This drawing
has long been considered a compositional design for
the high altarpiece of the church of Saint Nicholas in
Diksmuide, West Flanders, dated 1644 and lost during
the First World War. However, the watercolour and the
painting have little in common apart from the upright
composition and, remotely, the figures of Mary and the
child. Instead, a drawing in Antwerp and an oil sketch in
Kassel are more likely to be preparatory studies for the
Diksmuide painting.[1]

A drawing in the National Gallery of Ireland in
Dublin is closer to the Edinburgh design, albeit in
reverse.[2] D'Hulst pointed out that Jordaens sometimes
made reversed compositions in preparation for
paintings, but gave no further examples.[3] No painting
by Jordaens after either of those drawings is known.
There is, however, a painting from his workshop, which
is based on the Dublin design and may reflect a lost
painting by the master.[4] The Edinburgh drawing was
perhaps abandoned in the process of designing the
prototype for the Rotterdam painting or made for a
different commission altogether. Most likely, it is one
of the variations that Jordaens made on the subject of
the Adoration of the Magi for which he re-used and
reworked his own motifs, such as Joseph holding his
hat above his head, and the group of gazing people and
animals (for this practice see also cat.7). The style of
the drawing is close to the one in Dublin, although the
depiction of the draperies is less elaborate. VA

1. Museum Plantin-Moretus/Stedelijk Prentenkabinet, Antwerp,
inv.159; D'Hulst 1974, no.A290, fig.306. Staatliche Museen, Kassel, inv.
GK 992; Antwerp 1993, vol.1, no.A68, ill.
2. Inv.2615; D'Hulst 1974, no.A187, fig.201.
3. D'Hulst 1956, p.360.
4. Museum Boijmans Van Beuningen, Rotterdam, inv.1380; Giltaij
2000, p.95, ill.

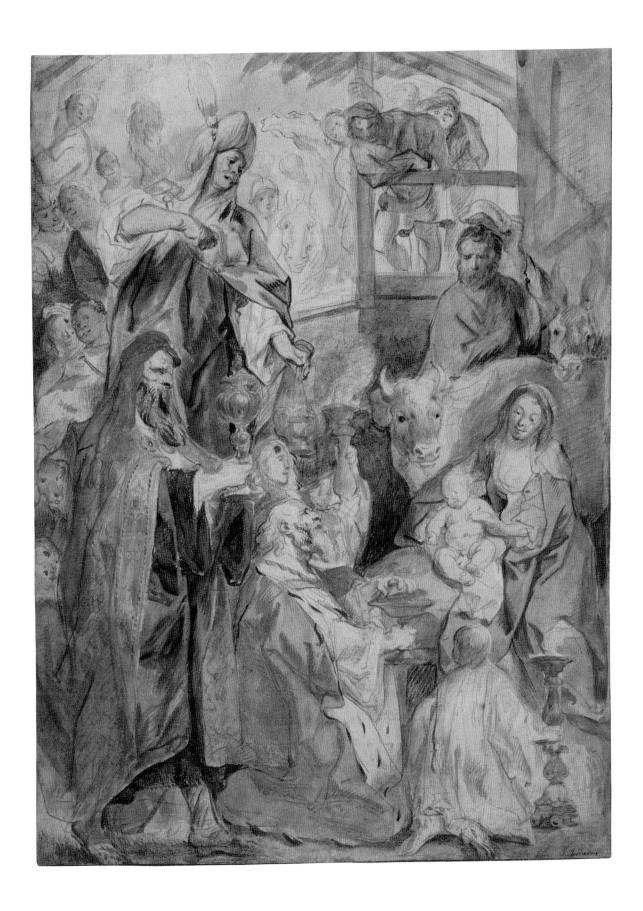

12 · Jacques (Jacob) Jordaens (1593–1678)
The Flight into Egypt, c.1652

Black and red chalk, brush and black ink, watercolour and
bodycolour, 249 × 170 mm (reverse blackened)
David Laing Bequest to the Royal Scottish Academy 1878,
transferred to the Scottish National Gallery 1910 (D 1666)

PROVENANCE: Benjamin West (1738–1820), London [Lugt 419];
possibly his sale London (Christie's), 14 June 1820 [L.9819], lot
100 ('Jordaens, one, the flight into Egypt, in black and white
chalks'); Thomas Lawrence (1769–1830), London [Lugt 2445];
David Laing (1793–1878), Edinburgh.

REFERENCE: NGS 1912, p.291; D'Hulst 1953, pp.73–4, fig.11;
D'Hulst 1956, pp.254–6, 376–7, no.135, fig.169; D'Hulst 1974,
vol.2, p.342, no.A257, vol.4, fig.273; D'Hulst 1982, p.237; Andrews
1985a, vol.1, p.41, vol.2, p.70, fig.282.

EXHIBITED: London 1927, no.625; London 1953a, no.262;
London 1953b, no.508; Antwerp 1954, no.317; Brussels 1965,
no.329; London 1966, no.49; Antwerp/Rotterdam 1966, no.99;
Ottawa 1968, no.246.

Described in the Gospel of Saint Matthew (2:13–23),
Mary, the Christ Child and Joseph, who is leading the ass
by its bridle, flee from Bethlehem to Egypt to escape the
Massacre of the Innocents ordered by King Herod (for
this subject see cat.22). The composition of this drawing
is closely related to an etching in reverse, inscribed in the
plate '*Iac. Iordaens inventor 1652*' (fig.26).[1] The dimensions

of the figures in the drawing and etching are virtually the
same. Moreover, the blackened reverse suggests that the
drawing was traced onto the copper plate, although no
indentations of the outlines can be detected. Whether it
was initially made as a compositional design for the etch-
ing is doubtful. More likely, it was a preparatory sketch
for a painting because of the indicated rounded top and
the use of watercolour – colouring being unnecessary for
an etching.[2]

The present drawing shows many similarities to
Jordaens's drawing *The Rest on the Flight into Egypt*
(fig.27).[3] Both compositions have rounded tops, a
feature that he did not use in any other drawing. The
dimensions of the paper and the sizes of the figures are
very close, too. Moreover, the many similarities in style
and the fact that the watercolours show subsequent
scenes of the same story may indicate that both drawings
were related to each other, possibly as preparatories for a
pair of paintings. Copies after *The Flight into Egypt*, prob-
ably made by pupils of Jordaens, are in Haarlem and in
Hamburg.[4] Both have arched tops and are executed
in watercolour.

The Gallery's drawing must date from about 1652,
the date on the etching. The inscription on the etch-
ing emphasises that the composition is an invention of
Jordaens. However, Jaco Rutgers recently suggested that
a group of seven etchings of 1652, including *The Flight into
Egypt*, was not executed by Jordaens, but by Rombout
Eynhoudts, a pupil of Cornelis Schut (see cats 22–4).[5] VA

1. Antwerp 1993, no.B93.
2. Jordaens's *The Descent from the Cross*, a preparatory
drawing for the etching of 1652, is essentially a 'bruneille',
executed in black chalk and little red chalk, brush and
brown ink and wash on brown prepared paper (Fondation
Custodia – Frits Lugt Collection, Paris, inv.4497); D'Hulst
1974, no.A274, fig.290; for the etching see Antwerp 1993,
no.B95, ill. (With thanks to Stijn Alsteens.)
3. D'Hulst 1974, no.A346, figs 362–3.
4. Teylers Museum, Haarlem, inv.O 039; Kunsthalle,
Hamburg, inv.22.062; D'Hulst 1974, nos C55–6, figs 538–9.
5. Rutgers 2012, pp.307–12.

Fig.26 | Jacques Jordaens, *Flight into Egypt*, 1652,
etching, 305 × 206 mm
British Museum, London (R, 2.73)

Fig.27 | Jacques Jordaens, *The Rest on the Flight
into Egypt*, c.1652, black chalk and watercolour,
258 × 158 mm
Fondation Custodia – Frits Lugt Collection, Paris (4845 1)

13 · Attributed to Peter Paul Rubens (1577–1640)
*Calvary, c.*1598–1600

Pen and brown ink over black chalk, brush and wash in blue, traces of squaring in black chalk, 255 × 250 mm
Watermark: hunter's horn in a shield (similar to Heawood 2639 (no place, 1602) and 2647 (Antwerp 1598)).
Professor Giles Robertson Gift in recognition of the Keepership of Keith Andrews 1985 (D 5134)

PROVENANCE: Annabel B. Squire Sprigge (1906–1980), Llanpumsaint; by whom given to her cousin Giles Robertson (1913–1987), Edinburgh (before 1977)[1]; on loan to the Scottish National Gallery (1977–1985).

REFERENCE: Andrews 1985a, vol.1, p.122, vol.2, p.222, fig.880; Andrews 1985b; Royalton-Kisch 1986, p.363 ('attribution to Rubens seems acceptable'); NGS 1989, pp.11–12, 16, ill.; Belkin 2009, vol.1, p.278, no.R22 (as not Rubens).

EXHIBITED: Edinburgh/London 1985; Edinburgh 1993; Edinburgh/London 1994, no.47; Edinburgh 1999, no.26.

1. Purportedly acquired on the London art market between about 1930 and 1950 by 'Henry', a friend of Annabel B. Squire Sprigge; letter Giles Robertson, 7 January 1985 (in curatorial file).
2. Leesberg 2012, nos 26, 351, ills. For a tentative source for the figure of Saint John see Andrews 1985b, p.531.
3. Both features can be found in other copies by Rubens, see Belkin 2009, nos 69, 73, figs 182, 196.
4. Belkin 2009, esp. vol.1, pp.26–41.
5. Museum Plantin-Moretus/Stedelijk Prentenkabinet, Antwerp; Belkin 2009, nos 14–57 and British Museum, London; Belkin 1977.
6. Städel Museum, Frankfurt, inv.806 ; Belkin 2009, no.110, fig.310, for other copies after Goltzius see nos 72, 108–9, figs 191, 306, 308.
7. British Museum, inv.00,9.30; Belkin 2009, no.13, fig.45.
8. Julius Held rejected the attribution to Rubens (letter of 13 December 1985), while Hans Mielke after a first refusal seemed to consider it (letters of 17 and 20 September 1984, all in curatorial file).

This *Calvary* – the crucifixion of Christ and the two thieves with attending figures – has been referred to as a jigsaw, made up of elements borrowed from other works. For the crucifixion, the artist took the motif of the three crosses from an engraving of Hendrick Goltzius's *Passion of Christ* series of about 1596–8 but slightly enlarged its scale. The group of riders on horseback is copied, albeit somewhat reduced, from another engraving by Goltzius (after a design by Johannes Stradanus), *Giovanni de' Medici before Francis I*, of about 1578.[2] The 'jigsaw' is missing a few pieces, however: the lance of the rider to the right ends abruptly where it hits the edge of Goltzius's print and the foreground is dominated by a huge void.[3]

The drawing was attributed to Rubens by Keith Andrews. Drawing faithful copies after prints was common practice for Rubens and formed an essential part of his training, as demonstrated by a number of examples from his early years – all in pen and ink and mostly without wash.[4] While some of them are copies of entire prints, such as those after Hans Holbein the Elder's woodcuts for the *Images of Death*, others record elements from one or several prints on a single sheet, as in Rubens's so-called *Costume Book*.[5] In another, much smaller group of copies Rubens fused figures from a number of prints to create new compositions, as in a sheet of about 1597–8, which combines figures from prints of the aforementioned *Passion* series by Goltzius.[6] It was the creative approach in those drawings in particular that convinced Andrews of Rubens's authorship of the *Calvary*. Closest to the *Calvary* is *A Turkish Prince on Horseback*, although the latter's attribution to Rubens is not universally accepted.[7]

The use of pen and ink with blue wash over black chalk in combination with brushwork in blue has no parallel in any secure drawings by Rubens. This in particular continues to lead scholars to doubt Andrews's attribution.[8]

14 · Attributed to Peter Paul Rubens (1577–1640), after Michelangelo Buonarotti (1475–1564) 'The Medici Madonna', 1600 or 1603

Black and some white chalk, 200 × 278 mm (laid down)
David Laing Bequest to the Royal Scottish Academy 1878,
transferred to the Scottish National Gallery 1910 (D 712)

PROVENANCE: Richard Cosway (1742–1821), London [Lugt
628]; probably his sale, London (Stanley's), 18 February 1822
[L.10182], lot 674 ('[Rubens], A Madonna Suckling the Child, in
black chalk'); David Laing (1793–1878), Edinburgh.

REFERENCE: Jaffé 1966b, p.145, note 22; Jaffé 1977, p.20;
Andrews 1985a, vol.1, p.71, vol.2, p.118, fig.470; Logan 1991,
p.316 (as not Rubens); Rosenberg 2000, p.247, no.NZ 400,
fig.56; Wood 2011, vol.1, pp.446–7, no.R23 (as Lodovico Cigoli).

EXHIBITED: London 1966, no.39; New York 1988, no.18;
Montreal 1992, no.62; Edinburgh/London 1995, no.205;
Bonn 2015, no.160.

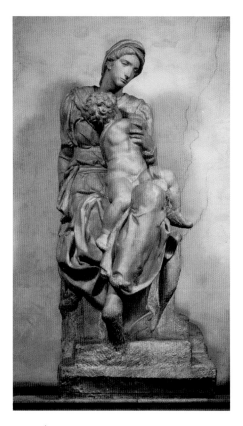

Fig.28 | Michelangelo, *Madonna and Child*, 1521–34,
marble, 226 cm high

Medici Chapel, San Lorenzo, Florence

Combining record and reinterpretation, the artist faith-fully copied Michelangelo's *Medici Madonna* (fig.28) on the right of this sheet, while on the left he allowed for a more natural movement of the Christ Child. The altered position of his left leg facilitates Christ's turn towards his mother, while his right arm is now stretched out to lift Mary's dress and reach for her breast.

During his Italian sojourn, Rubens copied a number of Michelangelo's works, mainly frescoes in the Sistine Chapel. He visited Florence twice, in 1600 and 1603, and could have seen the *Medici Madonna* in the Medici Chapel at San Lorenzo on either occasion. In Italy, Rubens frequently used black chalk to draw antique and, occasionally, modern sculptures. A juxtaposition of a copy and a variation similar to the present work can be found in Rubens's *A Youth in the Pose of the Spinario*, executed in red chalk and modelled on an antique bronze then (as now) displayed at the Palazzo dei Conservatori, Rome.[1] Rubens returned to the motif of the *Medici Madonna* (albeit in reverse) much later, in a pen and ink drawing of about 1624–7.[2]

The attribution of this drawing to Rubens was first suggested by Keith Andrews and endorsed by Michael Jaffé, but has not been accepted unanimously.[3] Indeed, the sketchy execution is uncharacteristic compared to his refined copies drawn after paintings and sculpture in Italy, such as the one after Michelangelo's *Night*, also from the Medici Chapel.[4] The Gallery's drawing is more reminiscent of chalk studies of about 1620 (see fig.33) but executed less vigorously. It should also be considered that the drawing has suffered in the past and is abraded in places, weakening its visual impact.

1. British Museum, London, inv.T,14.1; Held 1986, no.39, fig.23.
2. Hessisches Landesmuseum, Darmstadt, inv.AE 504; Burchard/D'Hulst 1963, no.131, fig.131.
3. Anne-Marie Logan and Stijn Alsteens reject the attribution to Rubens (emails 17 February 2016 and 4 March 2016 respectively).
4. Fondation Custodia – Frits Lugt Collection, Paris, inv.5251; Wood 2011, no.201, pl.7, fig.101.

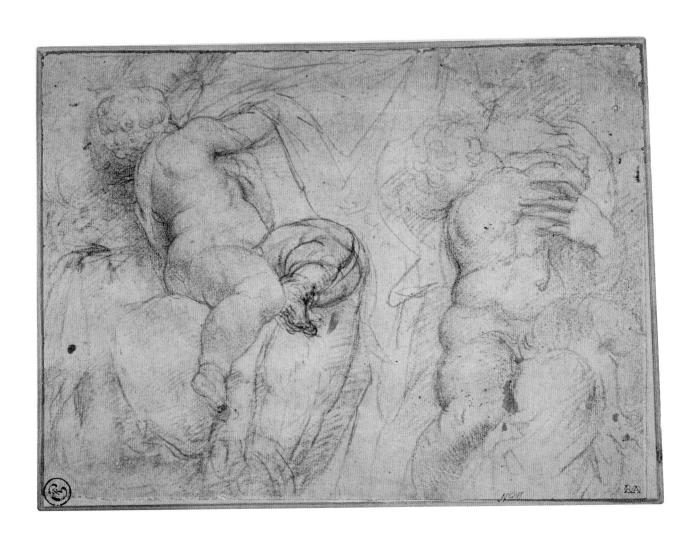

15 · Peter Paul Rubens (1577–1640)
Hero and Leander, c.1600–3

Pen and brown ink with wash, 204 × 306 mm
Inscriptions recto: 'Leander natans Cupidine prae úio'; verso:
'Sol', 'ad pedes lúx clarior', 'Maxima púlvis núbis instar/ aút
Caliginis', 'púlvis longo tractú/ a tergo albescit' (all in pen and
brown ink); 'Luca Cambiaso' (in pencil, faint, lower centre)
Watermark: three circles in a vertical row, the top circle crowned,
containing a cross, the middle one the initials 'G D', the lower one
a 'B' (similar to Heawood 251, Ireland 1656[?], but with different
initial in lower circle).
Purchased 1969 (D 4936)

PROVENANCE: Pierre-Jean Mariette (1694–1774), Paris [Lugt
2097]; possibly his sale Paris (Basan), 15 November 1775 – 30
January 1776 [L.2453], lot 1005 (under '*Dessins des Écoles
Flamande, Hollandoise et Allemande*', '[Rubens] *Une Esquisse à la
plume, d'une touche fine & legère, représentant la défaite de l'armée
des Assyriens, par l'Ange exterminateur. Autre Esquisse fait de même
pour le Déluge*'); purchased from Hans Maximilian Calmann
(1899–1982), London.

REFERENCE: Jaffé 1970; Jaffé 1977, p.70, fig.229; J. Müller-
Hofstede in Cologne 1977, pp.149, 198 (as copy by a pupil of
Rubens); Logan 1978, pp.422, 428; Held 1980, vol.1, p.589;
Logan 1983, p.416; Andrews 1985a, vol.1, pp.69–70, vol.2, p.115,
figs 464–5; McGrath 2005, pp.31–5; White 2005, p.215; Kopecky
2012, vol.1, pp.88–90, vol.2, no.51.

EXHIBITED: London 1977, no.11; Edinburgh/London 1985;
New York 2005, no.10; London 2005, no.16 (as attributed to
Rubens); Sydney 2015, no.50.

The recto (front) of this double-sided drawing relates
to Rubens's painting of *Hero and Leander*, famous lovers
from Greek mythology.[1] Every night Leander swam the
Hellespont (now known as the Dardanelles) strait to
visit Hero, guided by a light that she lit on her tower. One
stormy night the light was extinguished and Leander
drowned in the heavy seas. Recognising his body, Hero
threw herself into the sea and died as well. The paint-
ing depicts the dramatic climax of the story: nereids
surround Leander's body and Hero plunges into the
towering waves. The drawing also shows the rough sea
and a number of nereids. Leander is not easy to identify,
but may be the outstretched body floating in the centre.
Unlike the painting, the drawing does not show Hero.
A Latin inscription, very likely in Rubens's own hand,
seems to be an annotation rather than a description:
'Leander swimming as Cupid leads the way' (Ovid,
Heroides XVIII). As Cupid is not present in the drawing
either, it has been suggested that Rubens started with the
subject of a sea-storm or even a shipwreck – one of the
nereids clings to what seems to be a broken mast – and
only subsequently thought of this composition being
suitable for the Leander subject.

Dating the drawing is difficult. The *Hero and Leander*
painting mentioned above is usually dated to about
1604–6. On the verso (reverse) of the drawing, however,
Rubens made studies (fig.29), one of which closely
relates to the recently discovered painting *The Battle of
the Amazons*, which can be dated to about 1603–5.[2] This
study strongly recalls Leonardo's deluge drawings, and
some of the inscriptions on the verso, again in Rubens's
hand, seem to reflect on Leonardo's writings for his
projected *Libro di pittura* ('Book of Painting'). A date of
about 1603 has been suggested for the drawing because
Rubens may have seen both Leonardo's drawings
and writings in Madrid in 1603–4, when they were
in the possession of Pompeo Leoni, a sculptor at the
Spanish royal court. On the other hand, the script on
Rubens's drawing looks rather juvenile and includes
the distinctly northern European feature of the letter
'ú' (to distinguish it from the letter 'n'), which Rubens
abandoned in Italy. This would support an alternative
dating to 1600 or even before.

Michael Jaffé suggested that this sheet may have
been folded and inserted loose into Rubens's so-called
'pocketbook', which was lost in a fire in 1720.[3]

1. Yale University Art Gallery, New Haven, inv.1962.25; London 2005,
no.17, ill.
2. Private collection; London 2005, no.4, ill.
3. Jaffé 1970, pp.49–50; accepted by Logan 1978, p.428 and in New York
2005, p.85; rejected by White 2005, p.215.

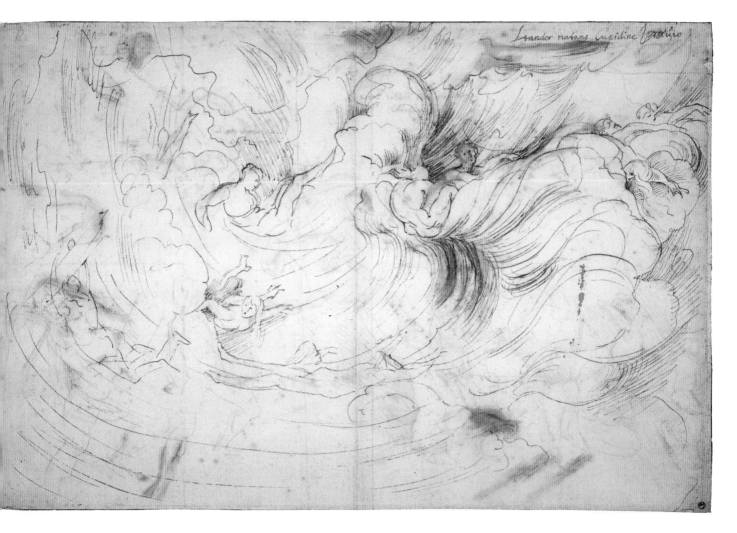

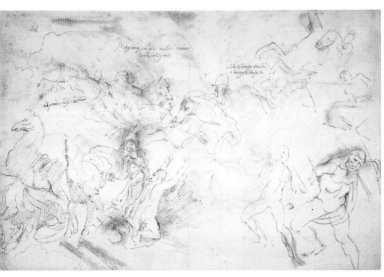

Fig.29 | Peter Paul Rubens, *The Battle of the Amazons and Studies for Samson* (verso of cat.15), *c.*1600–3
Scottish National Gallery, Edinburgh

16 · Attributed to Peter Paul Rubens (1577–1640), after Perino del Vaga (1501–1547)
The Shipwreck of Aeneas, 1602 or 1604–7

Pen and brown and black ink, brush and black ink, grey, blue, orange, grey-green watercolour and white bodycolour (partly discoloured), 438 × 711 mm (laid down)
David Laing Bequest to the Royal Scottish Academy 1878, on loan to the Scottish National Gallery 1966 (RSA I)

PROVENANCE: David Laing (1793–1878), Edinburgh.

REFERENCE: Jaffé 1966b, pp.140–1, pl.13; Jaffé 1977, p.47, pl.122; Andrews 1985a, vol.1, p.71, vol.2, p.118, fig.471; Logan 1987, p.68; Wood 2010a, vol.1, p.439, no.R12 (as not Rubens).

EXHIBITED: Edinburgh 1993.

The shipwreck of Aeneas is traditionally known as the '*Quos ego*' (Latin for 'Those which I'), after the words uttered by Neptune to the rebellious winds. On Juno's command, Aeolus, the god of winds, unleashed a storm to destroy Aeneas's ships, fleeing from Troy to Italy. However, Neptune, infuriated by Aeolus's intrusion into his realm, calmed the sea and allowed for the remainder of the battered fleet to take shelter on the African coast, where Aeneas founded Carthage (Virgil, *Aeneid*, 1:124–73).

This is a copy after a lost ceiling painting by Perino del Vaga in the Palazzo Doria in Fassolo outside (now part of) Genoa. According to the Tuscan artist and writer Giorgio Vasari, this was Perino's first work after entering the service of Andrea Doria, Genoa's powerful admiral and leader, in 1528. Although Rubens could have seen the painting during one of his visits to Genoa in 1604–7, it is

generally assumed that he used an engraving attributed to Giulio Bonasone as his starting point (fig.30). However, Rubens considerably enlarged the design and took many liberties with his model, such as raising the position of Neptune's trident, abandoning the figure underneath the horse's hoof and adding a prominent mast in the centre. Most notably, Rubens chose to depict a more dramatic moment of the story, just after Neptune has emerged from the sea, threatening the storm, while in Bonasone's print the right of the composition shows the already quiet sea and a flat horizon. Rubens also added watercolour and one wonders whether this, as well as the differences between the print and the drawing, reflects his own imagination or Perino's painting. Could it be that Rubens drew this copy when working on his *Aeneid* series of paintings for Vincenzo Gonzaga in Mantua around 1602?[1]

This impressive albeit much damaged (note Neptune's censored groin) creative copy was attributed to Rubens by Keith Andrews and Michael Jaffé. Little discussed in recent years, it deserves to be reconsidered.[2] The drawing has a distinct painterly appearance, partly because of vivid details such as the horses' heads and partly due to the dramatic distribution of light and shade. The latter as well as the technique compares to Rubens's *The Anointment of Christ* of about 1600–2, although this shows more hatching than the present drawing.[3]

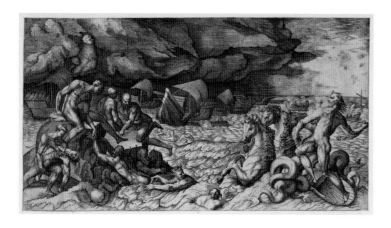

1. On this series see E. McGrath in London 1981, pp.214–15 and no.244; see also Logan 1987, pp.67–8. Rubens returned to the '*Quos ego*' subject in 1635 in a large painting for the 'Joyous Entry' of Ferdinand of Austria into Antwerp; Martin 1972, no.3, fig.7. See also cat.25.
2. Anne-Marie Logan and Stijn Alsteens reject the attribution to Rubens (emails 16 February 2016 and 4 March 2016 respectively).
3. Museum Boijmans Van Beuningen, Rotterdam, inv.MB 340; Rotterdam 2001, no.8, ill.

Fig.30 | Attributed to Giulio Bonasone, after Perino del Vaga, *The Shipwreck of Aeneas*, engraving, 230 × 429 mm
Scottish National Gallery, Edinburgh (P 2840)

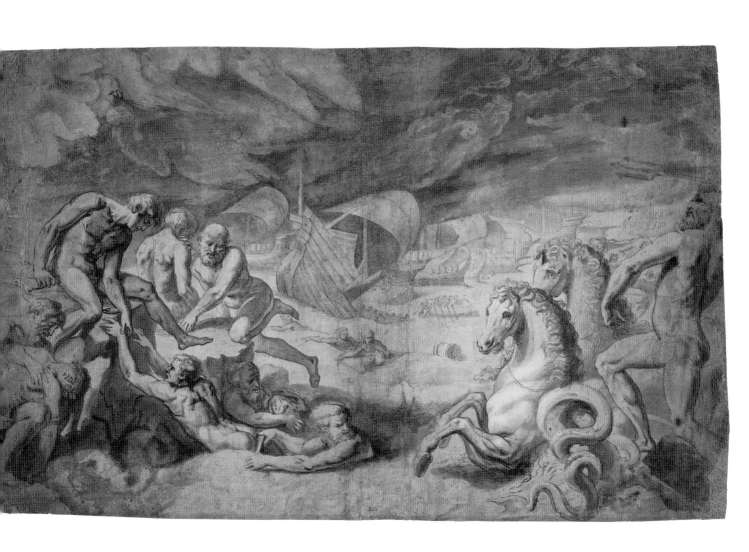

17A · Attributed to Peter Paul Rubens (1577–1640)
Saint Ignatius Pleading before Pope Julius III for the Establishment of a German Jesuit College in Rome, c.1606–8

Pen and brush and brown ink, brown wash, heightened with white, 117 × 103 mm (sheet), 114 × 100 mm (image)
Inscription lower right: '19' (in black chalk)
David Laing Bequest to the Royal Scottish Academy 1878, transferred to the Scottish National Gallery 1910 (D 1695)

PROVENANCE: Pierre-Jean Mariette (1694–1774), Paris [Lugt 2097]; his sale Paris (Basan), 15 November 1775 – 30 January 1776 [L.2453], lot 1004 (under 'Dessins des Écoles Flamande, Hollandoise et Allemande', '[Rubens], Quatre petits Sujets de la Vie de Saint Ignace, très – Spirituellement deffinés à la Plume & au bistre'); possibly Van Puten (D. c.1829), Paris [Lugt 2058][1]; David Laing (1793–1878), Edinburgh.

REFERENCE: Mariette 1858–9, pp.102–3; Held 1974, pp.249–50, pl.26b; König-Nordhoff 1976, pp.312–14, fig.5 (as possibly Rubens); Judson/Van de Velde 1978, vol.1, p.44, note 17; Renger 1980, p.431; König-Nordhoff 1982, pp.279–80, 301–5, fig.346 (as possibly Rubens); Held 1984, pp.50–3; Andrews 1985a, vol.1, p.70, vol.2, p.116, fig.466; Logan 1987, p.70.

EXHIBITED: London 1977, no.27; Edinburgh 1993; Munich 1997, no.35.

17B · Attributed to Jan-Baptist Barbé (1578–1649), after a drawing attributed to Peter Paul Rubens (1577–1640)
Saint Ignatius Pleading before Pope Julius III for the Establishment of a German Jesuit College in Rome (plate 64 in Vita Beati P. Ignatii Loiolæ Societatis Iesv Fvndatoris, Rome 1609), 1609

Engraving, 152 × 100 mm (plate), 114 × 97 mm (image)
Inscribed in the plate: 'Ignatij in Septemtrionis res apprime intenti/ studio, ac precibus Iulius III. Pont. Max. Collegium/ Germanicæ iuuentutis non minori Ecclesiæ Romanæ/ ornament, quam Germaniæ præsidio Romæ condit./ 64'
Purchased 1978 (P 2770)

PROVENANCE: Val Dieu Abbey (Aubel, Belgium), Library (their 'Bibliotheca Vallis Dei' stamp in dark purple); purchased from Günther Leisten (1921–1999), Cologne, 1978.

The Spaniard Ignatius of Loyola was the founder of the Jesuit Order (Society of Jesus), which received papal approval in 1540. The drawing illustrates Ignatius's plea to Pope Julius III to establish a Jesuit College for Germans in Rome, in 1552. He was successful; the college opened the same year and is still in existence. Ignatius was beatified in 1609 and on this occasion the Vita Beati P. Ignatii Loiolæ Societatis Iesv Fvndatoris was published; a second edition followed when he was canonised in 1622.[2] It comprises a title page and a portrait of Ignatius and a series of seventy-nine engravings

illustrating his life, each accompanied by a short Latin inscription. The book does not contain any reference to the authors of the texts or the prints. The present drawing is a preparatory study for plate 64.

The Vita was printed in Rome in 1609 – Rubens had returned to Antwerp the year before – but had largely been compiled between 1605 and 1606, just after the canonisation process for Ignatius had been commenced by Pope Paul V.[3] Rubens returned to Rome in late 1605 and, given his commissions from the Jesuits in Mantua and Genoa, he might have been a suitable choice for the Jesuit governors in Rome too. The engravings have been attributed to Jan-Baptist Barbé, a printmaker from Antwerp, then active in Rome, where he collaborated on at least one occasion with Rubens, engraving the latter's Holy Family.[4]

The drawing was in the collection of the famous French collector and connoisseur Pierre-Jean Mariette who attributed it and three others for the same print series, now lost, to Rubens.[5] Only one other drawing for this project survives. It was discovered by Julius Held

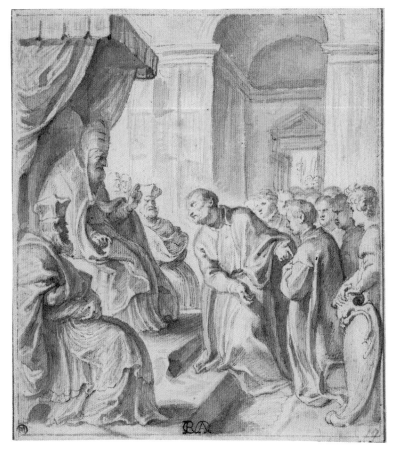

actual size

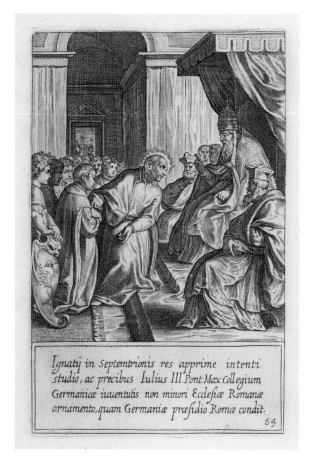

Ignatij in Septemtrionis res apprime intenti
studio, ac precibus Iulius III.Pont.Max.Collegium
Germaniæ iuuentutis non minori Ecclesiæ Romanæ
ornamento,quam Germaniæ præsidio Romæ condit.

64

and he published both as by Rubens.[6] No other designs for prints from Rubens's Italian sojourn are known and his earliest surviving, for the *Missale Romanum*, date from 1613, five years after his return to Antwerp.[7] Those do not compare closely to the Ignatius drawing. Moreover, one distinct feature of the present sheet, the broken, almost stippled lines and contours, does not occur anywhere in Rubens's oeuvre.

1. Not in his sale Paris (Duchesne), 14–15 December 1829 [L.12183].
2. König-Nordhoff 1982, pp.118–21, 277–321.
3. König-Nordhoff 1976; König-Nordhoff 1982, pp.118–21, 305–6.
4. König-Nordhoff 1982, p.305, fig.423; Duverger 1995.
5. Mariette 1858–9, pp.102–3.
6. Museé du Louvre, Paris, inv.22239; Held 1972 and 1974, pp.259–60.
On stylistic grounds, Held attributed the designs for ten plates to Rubens: plates 64 (drawing in Edinburgh), 66, 67, 68 (drawing in Paris), 69, 73, 74, 77, 78, and the title page.
7. Judson/Van de Velde 1978, nos 6a, 7a, 8a, figs 48, 50, 52.

18 · Anonymous Italian artist, after Raphael (1483–1520), enlarged and retouched by Peter Paul Rubens (1577–1640)
Prudence, c.1540–60 and c.1609

Red chalk, brush and red ink and some cream-coloured bodycolour, 161 × 187 mm (core drawing), 181 × 212 mm (with L-shaped addition)
Inscription lower right: '29' (in pencil)
David Laing Bequest to the Royal Scottish Academy 1878, transferred to the Scottish National Gallery 1910 (D 1787)

PROVENANCE: Prosper Henry Lankrink (1628–1692), London [Lugt 2090]; David Laing (1793–1878), Edinburgh.

REFERENCE: Andrews 1961, no.29, ill.; Burchard/D'Hulst 1963, vol.1, p.42, under no.22; Jaffé 1967, p.101, note 33; Pope-Hennessy 1970, p.240; Jaffé 1977, pp.24–5 (all as Rubens); Andrews 1985a, vol.1, p.71, vol.2, p.117, fig.469; Jaffé 2002, p.644 (as perhaps entirely Rubens); Howarth 2003, pp.120–1 (as reworked by an eighteenth-century hand, not by Rubens); Wood 2010a, vol.1, pp.151–3, no.1, vol.2, fig.1.

EXHIBITED: Edinburgh/London 1985 (as Rubens); Edinburgh 1993 (as Rubens); Edinburgh 1999, no.28; Edinburgh/Nottingham 2002, no.19; Edinburgh 2012.

This figure of *Prudence* is taken from Raphael's fresco *The Cardinal Virtues*, which Rubens saw in the Vatican's Stanza della Segnatura in Rome in 1601–2 or 1606–8 (fig.32). While the drawing was first published by Keith Andrews as a copy entirely by Rubens, he later suggested that only the addition of the L-shaped piece of paper and a few retouches in the core drawing are by Rubens.[1] Indeed, why would Rubens have cropped the figure's right foot and the putto's wings only to add a strip of paper to his own drawing and complete them again? Moreover, the additions on this piece of paper are executed mostly in brush and red ink, as are a few retouches in the core drawing, while the latter is in red chalk. Rubens changed Prudence's profile and the shape of the mirror, adding a handle. Julia Lloyd Williams classified the core drawing as mid- to late-sixteenth century Italian while Jeremy Wood argued that it was a copy from Raphael's workshop.[2] It seems more likely to date from about 1540–60 and to have been executed in Rome.[3]

Some differences between the core drawing and the fresco suggest that the former is not a copy after the latter, nor after Agostino Veneziano's engraving of *Prudence*

(fig.31). Particularly telling are the position of the figure, sitting on the floor rather than elevated on a step, resulting in different formations of folds in her clothing – lying flat instead of flowing – and an altered view of Prudence's left hand. While this seems to be in favour of Wood's attribution of the core drawing to Raphael's workshop, it should be noted that Raphael employed highly finished preparatory drawings only later in his career.

From the late seventeenth century onwards, connoisseurs have observed that Rubens repeatedly retouched drawings by other artists. Valerius Röver, the eminent eighteenth-century Dutch collector, called such works 'Rubenised' ('*Rubenisato*').[4] An intervention similar to the one on *Prudence*, also with brush and red ink, can be found in another red chalk drawing, a copy after Adriaen Key's *Figure of a Nude Man Fleeing*. Kristin Belkin dated Rubens's retouchings on that drawing to about 1609, a date that seems plausible for *Prudence*, too.[5]

1. Andrews 1961, no.29; Andrews 1985a, vol.1, p.71.
2. Lloyd Williams in Edinburgh 1999, p.68; Wood 2010a, vol.1, p.152.
3. With thanks to Joachim Jacoby and Aidan Weston-Lewis.
4. Plomp 2005, p.51 (quote); Belkin 2009, vol.1, pp.67–70; Wood 2010a, vol.1, pp.77–84, both with earlier literature.
5. The Courtauld Gallery, London, inv.PG 322; Belkin 2009, no.112, fig.314, pl.12.

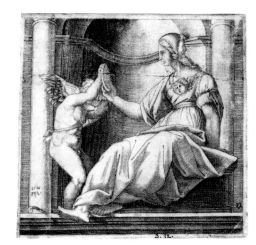

Fig.31 | Agostino Veneziano, after Raphael, *Prudence*, 1516, engraving, 130 × 137 mm
British Museum, London (1874, 0808.247)

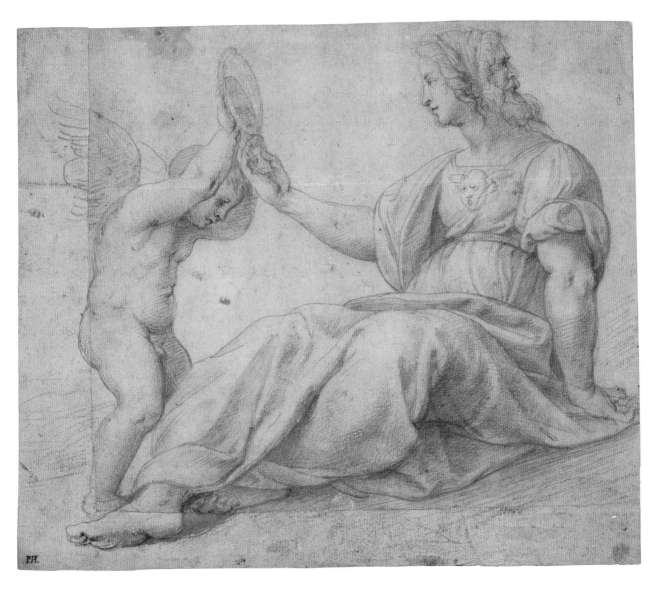

Fig.32 | Raphael, *Prudence* (detail from the fresco
The Cardinal Virtues), 1508–11
Stanza della Segnatura, Musei Vaticani, Rome

19 · Workshop of Peter Paul Rubens (1577–1640)
Saint Gregory of Nazianzus Subduing Heresy, 1620

Red chalk and white bodycolour (partly discoloured),
299 × 385 mm (laid down)
Inscriptions lower left: 'P.P. Rubens.' (in black chalk); on
the verso: 'S Ambrosius' (in black(?) ink)[1]
Watermark: hunter's horn crowned by a cross and a '4'(?)
Keith Andrews Bequest 1991 (D 5321)

PROVENANCE: Keith Andrews (1920–1989), Edinburgh.

Saint Gregory, one of the Doctors of the Church, was a
fourth-century Greek theologian, Bishop of Nazianzus
and Archbishop of Constantinople (today Istanbul).
Revered in the Orthodox Catholic Church as one of the
Three Holy Hierarchs, he is rarely depicted in Western
art. Gregory has raised his crosier to fight off a demon,
symbolising heresy, which was widespread among the
Eastern churches in his time. The drawing relates to one
of the largest and most prestigious commissions Rubens
ever received.

On 29 March 1620 Rubens signed a contract with the
Jesuits to provide thirty-nine paintings for the ceilings of
the aisles and galleries in the recently built Jesuit Church
(today Saint Carlo Borromeo) in Antwerp. The contract
specified that Rubens himself would make small oil
sketches ('*teekeninge … in't Cleyne*'), while the full-scale
canvases might be carried out by his pupils (the young
Van Dyck is the only one mentioned by name), the mas-
ter adding the final touches. It was agreed that the paint-
ings should be delivered within nine months and Rubens

Fig.33 | Peter Paul Rubens, *Saint Gregory Nazianzus Subduing Heresy*, 1620, black chalk, 412 × 475 mm
Harvard Art Museums, Cambridge, Mass. (1969.168)

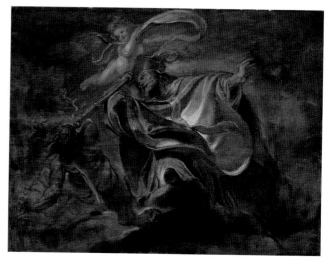

Fig.34 | Peter Paul Rubens, *Saint Gregory of Nazianzus Subduing Heresy*, 1620, oil on panel, 67.9 × 83.8 cm
Albright-Knox Art Gallery, Buffalo (1952:14)

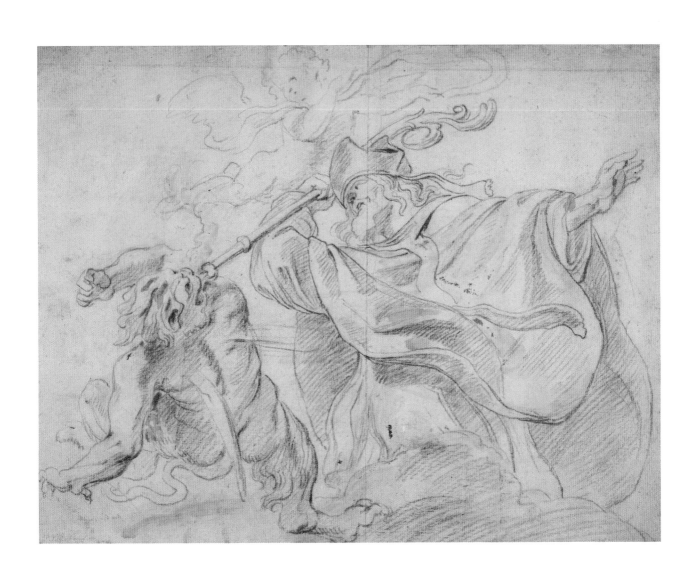

would receive the royal fee of 7,000 guilders on their completion. An appendix listed the proposed subjects for the paintings, including a 'St Gregory of Nazianzus'.[2]

The drawing entered the collection from Keith Andrews's estate as an anonymous copy after Rubens. However, it seems more likely to be a product of his workshop. Rubens started with a large black chalk drawing, one of only two surviving preparatory drawings for this huge project (fig.33).[3] He simplified the composition for the oil sketch, reducing the number of figures and adapting it for viewing from below and the octagonal shape of the canvas (fig.34).[4] At first glance, the Edinburgh drawing seems to be a faithful copy of the oil sketch. However, it has been reworked in white bodycolour, to indicate highlighted areas. Some of these differ from the oil sketch, such as the central highlight on the saint's chasuble and those on the head of the demon. It seems unlikely that a copyist would have taken these liberties. More importantly, Gregory's right foot,

protruding under his alb, was erased from the drawing, a 'ghost image' still being visible along with the shadow of the foot underneath. The ceiling paintings were lost in a fire in 1718, but fortunately two artists drew copies of the complete series earlier the same year: the Dutchman Jacob de Wit and Christian Benjamin Müller from Dresden (fig.35). The latter is regarded as the more faithful of the two.[5] None of the copies shows Gregory's foot. Therefore, it seems likely that this change to the red chalk drawing was made in Rubens's studio, under the master's supervision (if not by himself), before the painting was executed.

1. Visible on the recto and in transmitted light.
2. Martin 1968, pp.31–43, 213–19 (quote p.214); Held 1980, vol.1, pp.33–8.
3. Held 1986, pp.125–6, no.147, pl.146.
4. Held 1980, vol.1, pp.60–1, no.36, vol.2, pl.37; Wieseman in Greenwich/Cincinnati/Berkeley 2004, pp.118–21, no.9, ill.
5. On these copies see Martin 1968, pp.44–53.

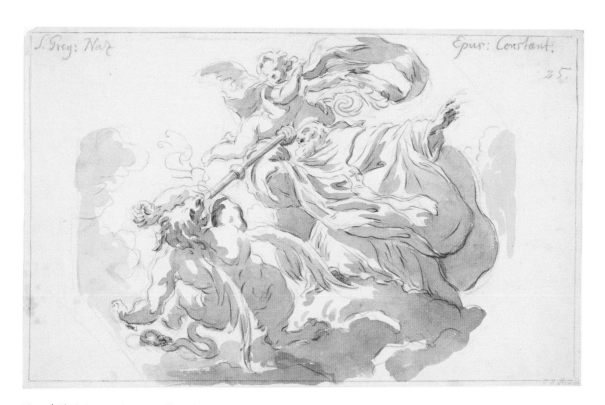

Fig.35 | Christian Benjamin Müller, after Peter Paul Rubens, *Saint Gregory Nazianzus Subduing Heresy*, 1718, pen and brown ink over black chalk, grey wash, 190 × 305 mm
Stedelijk Prentenkabinet – Museum Plantin-Moretus, Antwerp (PK.OT.00427)

20 · Peter Paul Rubens (1577–1640), after a drawing attributed to Abraham van Diepenbeeck (1596–1675), after Primaticcio (1504–1570)
Ulysses, Telemachus and Two Herdsmen Washing Themselves, c.1635

Watercolour and bodycolour in green, red, purple, brown and white, 293 × 432 mm (laid down)
David Laing Bequest to the Royal Scottish Academy 1878, transferred to the Scottish National Gallery 1910 (D 1677)

PROVENANCE: David Laing (1793–1878), Edinburgh.

REFERENCE: Held 1959, vol.1, pp.53, 162, under no.166; Burchard/D'Hulst 1963, p.252, under no.163; Logan 1978, pp.434–5 (as Theodoor van Thulden?); Andrews 1985a, vol.1, p.88, vol.2, p.153, fig.580 (attributed to Van Thulden); Béguin/Guillaume/Roy 1985, pp.294–5, fig.319; Held 1986, p.140, under no.181; Logan 1987, p.75 (as not Rubens); Wood 1990, pp.31–5, fig.28; Howarth 2003, p.121 (as not Rubens); Wood 2010a, vol.1, p.76; Wood 2011, vol.1, pp.295–9, no.214, vol.2, fig 135.

EXHIBITED: Antwerp 1956, no.112; London 1966, no.40; London 1977, no.39; Edinburgh/London 1985 (as Van Thulden); Edinburgh/Nottingham 2002, no.62.

This watercolour belongs to a group of five made after Primaticcio's series of frescos for the Galerie d'Ulysse at Fontainebleau (1540–60), lost when the building was demolished in 1738–9.[1] The subject is taken from the ancient Greek poet Homer's *Odyssey*. When Ulysses finally reached his home after twenty years of warfare in Troy and an often-interrupted return journey, he found his house full of suitors competing for his wife Penelope's hand, as it was assumed that he had died. Ulysses killed the suitors, while his son Telemachus hanged Penelope's disloyal servants with the help of two herdsmen. After the carnage, they washed themselves. Primaticcio merged two scenes from this story into one, which has led to confusion about the correct identification of the subject in the past.[2]

Rubens saw the Galerie d'Ulysse on one of his extended visits to Paris between 1622 and 1625. However, close comparison with a series of copies in black chalk after Primaticcio's frescos confirms that those were his starting point (fig.36). This set of drawings was traditionally attributed to Theodoor van Thulden, who made etchings (in reverse) after Primaticcio's murals in 1632–3 (fig.37). More recently, an attribution to Abraham van Diepenbeeck has been suggested for the chalk copies.[3] Both Van Thulden and Van Diepenbeeck worked in Paris in the early 1630s, collaborated with Rubens after their return to Antwerp around 1635 and could have supplied the master with drawings.[4]

The attribution of the present watercolour to Rubens, first suggested by Alfred Scharf in 1955 (note on the mount), is not a straightforward one either.[5] Rubens's only secure watercolour is a preparatory study of an entirely different character, resembling

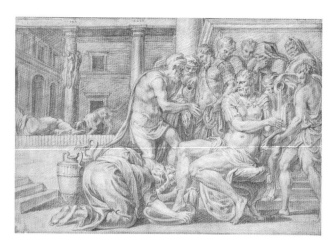

Fig.36 | Attributed to Abraham van Diepenbeeck, after Primaticcio, *Ulysses, Telemachus and Two Herdsmen Washing Themselves*, c.1632, black chalk, 231 × 341 mm

Albertina, Vienna (8978)

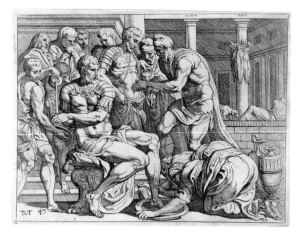

Fig.37 | Theodoor van Thulden, after Primaticcio, *Ulysses, Telemachus and Two Herdsmen Washing Themselves*, 1633, etching, 192 × 255 mm

Rijksmuseum, Amsterdam (RP-P-OB-66.774)

the vigorous handling of his oil sketches.[6] Rubens's model was the chalk drawing (fig.36) but he introduced some significant changes, such as omitting the cruel background scene and removing the stairs, allowing for a more spacious arrangement of the figures and their movements. He also clarified the ambiguity of the disembodied hand pouring water over the herdsmen's hands and introduced Telemachus's right arm, drying his hands. These improvements are certainly in favour of an attribution to Rubens, who probably consulted Homer's text to penetrate the ambiguity of Primaticcio's conflated image. They are difficult to explain if the watercolour was by either Van Diepenbeeck or Van Thulden, whose own copies lack this clarity. The void in the background, the missing legs of the man on the right and the lack of modelling in some areas, particularly the herdsman on the left, may indicate that the watercolour is partly unfinished.[7] This would also explain the lighter, almost translucent appearance of the present sheet compared to the other four of the group.

1. On the Galerie d'Ulysse see Béguin/Guillaume/Roy 1985.
2. For the correct identification see Wood in Edinburgh/Nottingham 2002, p.77; Wood 2011, pp.296–7.
3. Wood 1990; Wood 2011, vol.I, pp.268–9.
4. For a balanced view on these debated attributions see Béguin 1991.
5. Wood 2011, pp.270–1, 298–9 (with further references). With thanks to Anne-Marie Logan, who suggested that Rubens worked up a copy that another artist had drawn for him (email 16 February 2016). Despite a few minor 'pentimenti' (corrections), I find it difficult to see evidence of two different artists working on this sheet.
6. New York 2005, no.106, ill.
7. Wood 2011, vol.I, pp.297–8.

21A · Peter Paul Rubens (1577–1640)
Four Women Harvesting, c.1635

21B · Peter Paul Rubens (1577–1640)
Eight Women Harvesting, c.1635

CAT. 21A
Black and red chalk with some white heightening, pen and brown ink, on oatmeal paper, 184 × 208 mm
Inscriptions: 'blauv[v]' (in brown ink, next to the figure lower right); 'Rubens.' (in black chalk, lower left); '18' (in black chalk, top centre)
David Laing Bequest to the Royal Scottish Academy 1878, transferred to the Scottish National Gallery 1910 (D 1490)

CAT. 21B
Red and black chalk, pen and brown ink, on oatmeal paper, 222 × 258 mm
Inscription lower right: 'Rubens' (in brown ink)
David Laing Bequest to the Royal Scottish Academy 1878, transferred to the Scottish National Gallery 1910 (D 1500)

FOR BOTH SHEETS:

PROVENANCE: Prosper Henry Lankrink (1628–1692), London [Lugt 2090] (b, but presumably also a); David Laing (1793–1878), Edinburgh.

REFERENCE: NGS 1912, p.298 [a, b]; Scharf 1949, p.139, fig.15 [a]; Held 1959, vol.1, p.121, nos 59–60, vol.2, plates 65–6; Andrews 1961, no.28 [b]; Burchard/D'Hulst 1963, vol.1, pp.239–41, nos 153–4, vol.2, figs 153–4; Kuznetsov 1974, nos 142–3; Adler 1982, pp.189–90, nos 78–9, figs 163–4; Andrews 1985a, vol.1, pp.70–1, vol.2, pp.116–17, figs 467–8; Held 1986, p.146, nos 195–6, p.262, figs 186–7; Kopecky 2012, vol.2, no.24 [a].

EXHIBITED: London 1938, no.588 [a, b]; Rotterdam 1948, no.137 [a, b]; Brussels/Paris 1949, no.109 [a, b]; Leicester 1952, nos 59–60; Antwerp 1956, nos 102–3; Edinburgh 1976, no.71 [b]; London 1977, nos 193–4; Washington/Fort Worth 1990, nos 59–60; Edinburgh 1993.

These two sheets, executed on the same type of paper and in the same technique, possibly once formed a single drawing that was cut into two at an unknown time, as Keith Andrews suggested.[1] Judging from the composition, the *Four Women Harvesting* would have been on the left, and the *Eight Women Harvesting* on the right. Figure studies such as these, which do not relate to any of Rubens's commissions, are rare in his oeuvre.

In 1635, aged fifty-eight, Rubens purchased the estate of Het Steen near Elewijt, about twenty miles south of Antwerp (where he had bought a large house already in 1610). Rubens and his family spent considerable time in the country and the rural surroundings immediately inspired him to turn to large landscape paintings.[2]

The women in the drawings are occupied with gathering, binding and carrying sheaves. The swift and sketchy execution suggests that the chalk drawings were done outdoors and from life, the pen and ink lines perhaps added in the studio. However, the motifs may also have been inspired by works of Pieter Bruegel the Elder. Rubens was an avid collector and owned twelve paintings by (or after) the master. The colour note 'blue' (blauv[v]), probably added by Rubens himself, perhaps indicates that these sketches were made in preparation for a painting. However, none of the figures corresponds with his existing paintings. Rubens painted a number of landscapes in his late career and some show small figures in similar poses and occupations, such as *Return from the Harvest* (Palazzo Pitti, Florence), *Autumn Landscape with the Castle Steen* (National Gallery, London) and *Landscape with a Rainbow* (Wallace Collection, London), all from about 1635–6.[3]

1. Examination with transmitted light has been inconclusive, although it confirmed that both sheets are the same type of paper. We have been unable to identify with certainty drawn lines continuing over both sheets. (With thanks to Graeme Gollan.)
2. London 1996, pp.59–78.
3. London 1996, figs 58–9, 99.

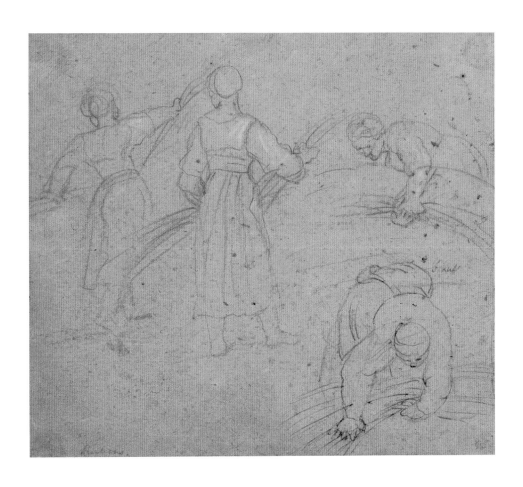

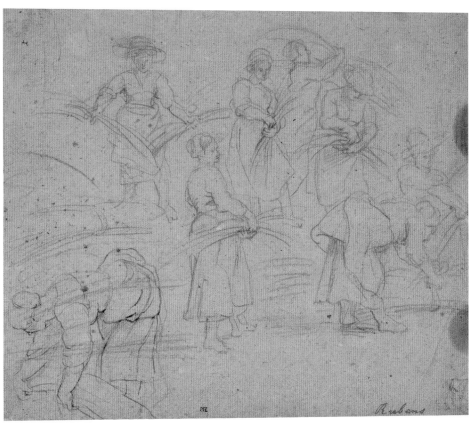

22 · Cornelis Schut (1597–1655)
The Massacre of the Innocents, c.1624–7

Pen and brown ink over black chalk, brown wash, 217 × 182 mm (laid down)
Inscription on the verso of the mount: 'G. de Crayer' (in pencil)
William Findlay Watson Bequest 1881 (D 3118)

PROVENANCE: William Findlay Watson (1810–1881), Edinburgh.

REFERENCE: Andrews 1971, vol.1, pp.99–100, vol.2, p.121, fig.690 (as Mattia Preti); Foucart 1979, p.154, fig.3; Andrews 1985a, vol.1, p.79, vol.2, p.133, fig.519; Wellesley/Cleveland 1993, pp.207–8, under no.61, fig.XVII; Wilmers 1996, pp.70–2, under no.A9, p.348, fig.A9a; Luijten 2006, p.145.

EXHIBITED: Edinburgh 1981, no.32; Edinburgh 1993.

The Gospel of Saint Matthew relates that Herod, King of Judea, was scared by the Magi's prophecy that Christ, the king of the Jews, had been born in Bethlehem. To secure his reign against this potential future challenger, Herod called for all boys under the age of two years to be killed. Mary, Joseph and the Christ Child escaped to Egypt (Matthew 2:1–16). The murdered innocents have been venerated as proto-martyrs and the story has been depicted in art since the fifth century.

This is the first preparatory drawing for a large painting, executed in Rome, where the artist is documented as living between 1624 and 1627, although he may have arrived a few years earlier. The painting, today in the Church of the Holy Trinity in Caen (France), was recorded in the post-mortem inventory of the Roman banker and collector Vincenzo Giustiniani in 1638. He may indeed have been Schut's patron, as he also owned the supposed pendant painting by Schut, *The Adoration of the Magi*, today in Caen, too.[1]

Schut's vigorous pen strokes and strong chiaroscuro correspond with the dramatic events they describe. This rapid, spontaneous first design – the composition was only thinly outlined in chalk before – defines the setting, the grouping of the figures and, by means of the wash, the distribution of light and shade. It was followed by a more refined drawing of about the same size and an oil sketch, probably for approval by the patron (figs 38, 39).[2]

1. Wilmers 1996, no.A9, fig.A9 (*Massacre*) and no.A4, fig.A4.
2. Wilmers 1996, under no.A9, figs A9b (drawing), A9c (oil sketch, as copy).

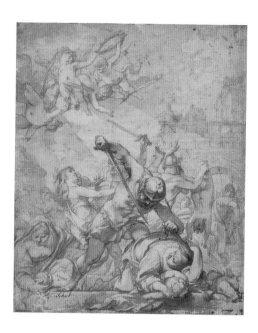

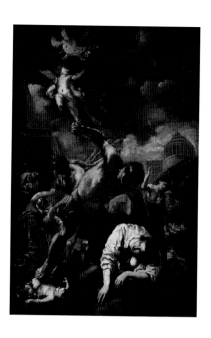

Fig.38 | Cornelis Schut, *Massacre of the Innocents*, c.1624–7, pen and brush and brown ink over black chalk, brown wash, 224 × 187 mm
Yale University Art Gallery, New Haven (1961.65.62)

Fig.39 | Cornelis Schut, *Massacre of the Innocents*, c.1624–7, oil on canvas, 50 × 33.8 cm
Princeton University Art Museum, Princeton (863)

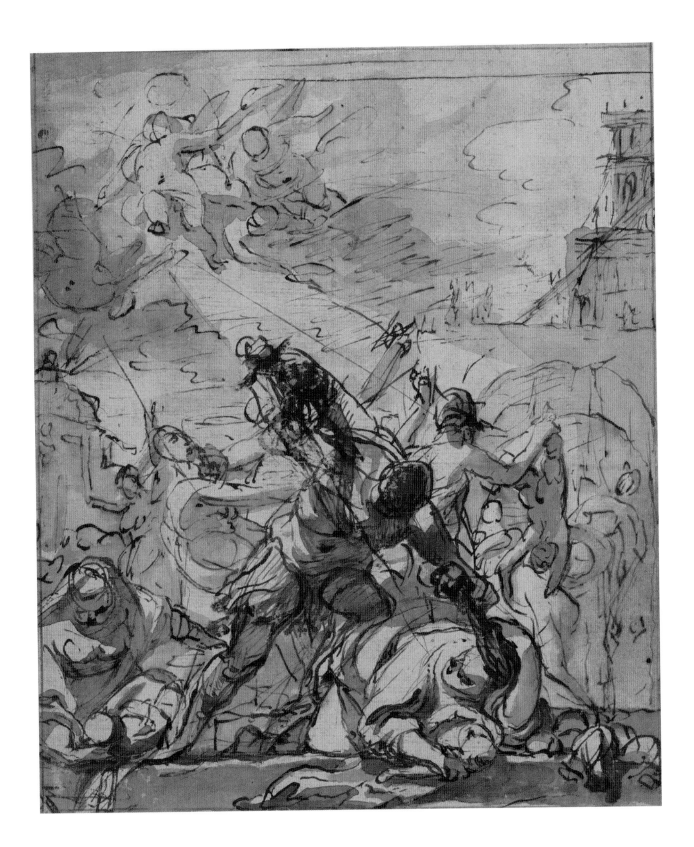

23 · Cornelis Schut (1597–1655), after Gerard Seghers (1591–1651)
Belgica Imploring Charles V to Send the Cardinal Infante as her Protector, c.1635–6

Brush and black, brown, grey and white oil (?) paint, on paper oiled for tracing, 284 × 393 mm (squared in black chalk, incised, laid down)
Inscription lower right: '230[6?]' (in black ink)
William Findlay Watson Bequest 1881 (D 2882)

PROVENANCE: Count Moriz von Fries (1777–1826), Vienna [Lugt 2903]; William Findlay Watson (1810–1881), Edinburgh.

REFERENCE: Vlieghe 1972, p.190, fig.3; Andrews 1985a, vol.1, pp.79–80, vol.2, p.134, fig.521; Wilmers 1996, p.267, note 202.

This drawing depicts an allegorical scene. Belgica (the Southern Netherlands) on the left pleads with the crowned Emperor Charles V, seated on the right and accompanied by Philip II, Philip III and the Infanta Isabella (all deceased), to send the Cardinal Infante Ferdinand of Austria as her protector. In the centre, King Philip IV of Spain hands his younger brother Ferdinand the governor's baton. This allegory refers to Ferdinand's recent success as a military commander and appointment as the Governor of the Spanish Netherlands.

On 6 September 1634, at the height of the Thirty Years War, the Catholic Habsburg forces and the Protestant Swedish armies and their German allies met at the Battle of Nördlingen (Swabia). The Cardinal Infante Ferdinand of Austria and his cousin King Ferdinand III of Hungary, commanders of the Habsburg troops, won a crushing victory. The Cardinal Infante, Governor General of the Spanish Netherlands since 1633, took up residence in Brussels soon afterwards.

On 18 January 1635, Ferdinand held his 'Joyous Entry' into the town of Ghent, a tradition to welcome rulers, which had been established in the Netherlands in the late Middle Ages.[1] The programme was devised by the Jesuit Guilielmus Becanus. Gaspar de Crayer, Cornelis Schut, Gerard Seghers and Theodoor Rombouts, as well as local artists, were commissioned to produce large paintings celebrating Ferdinand and his great-grandfather, Emperor Charles V. These canvases were displayed on huge triumphal arches at the Vrijdagmarkt, the town's main square (fig.40). These enormous wooden structures were temporary and taken down after the festivities, and few of the monumental paintings (or even fragments of them) survive.[2]

To commemorate the occasion and the imagery of Ferdinand's entry, a folio book was published the year after, lavishly illustrated with forty-two etchings.[3] The Ghent city council commissioned Schut to oversee the production of the book, including the printing plates.[4] Schut also provided the preparatory drawings for the printmakers; the present one is for plate 26 (fig.41). It shows the scene crowning the *Arcus Carolinus* (Charles V's Arch), painted by Gerard Seghers and now lost.[5] The drawing reverses the original composition, so that the print reproduces the painting in the correct orientation. As the crowning of the arch was a cut-out, there is no background in either of the works.[6] Belgica's plea is inscribed in the print, '*Quem das finem, rex magne, laborum?*' ('What end are you giving, great king, to these labours?'), a quote from the ancient Roman poet Virgil's *Aeneid* (1:241).

1. Van de Velde/Vlieghe 1969; for Schut's contribution see also Wilmers 1996, pp.83–90.
2. Van de Velde/Vlieghe 1969, pp.63–71.
3. Becanus 1636.
4. Van Duyse 1844, pp.4–6.
5. Van de Velde/Vlieghe 1969, pp.59–60, no.5, p.93, no.15. For another such drawing of this series by Schut see Wilmers 1996, no.A21, fig.A21a. Stijn Alsteens kindly drew my attention to a third one, *Charles V Crowned Emperor by Clement VII*, also by Schut and very similar in execution to the Gallery's drawing (Printroom of the Royal Library, Brussels, inv. S. V 84466); this is a preparatory for plate 24.
6. For a surviving fragment of such a full-scale cut-out after Rubens's design for Ferdinand's 'Joyous Entry' into Antwerp (see cat.25), see Martin 1972, p.69, fig.19.

Fig.40 | Cornelis Schut, *The Arcus Carolinus on Vrijdagmarkt*, 1636, etching, 295 × 389 mm
Rijksmuseum, Amsterdam (RP-P-OB-76.439)

Fig.41 | Cornelis Schut, *Quem das finem rex magne laborum*, 1636, etching, 307 × 397 mm
British Museum, London (1875,0710.5880)

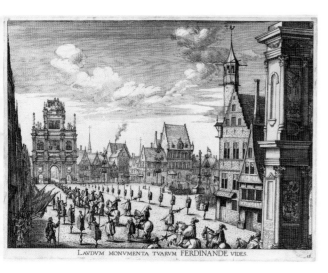

LAVDVM MONVMENTA TVARVM FERDINANDE VIDES.

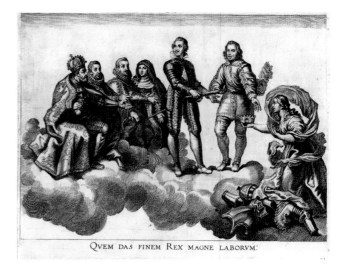

QVEM DAS FINEM REX MAGNE LABORVM!

24 · Cornelis Schut (1597–1655)
The Coronation of the Virgin with Saints, c.1639–40

Pen and brown and black ink with some white bodycolour, over a counterproof of a proof impression of the first state of his etching, 397 × 290 mm (laid down)
David Laing Bequest to the Royal Scottish Academy 1878, on loan to the Scottish National Gallery 1974 (RSA 1052)

PROVENANCE: John M'Gowan (D.1803), Edinburgh [Lugt 1496][1]; David Laing (1793–1878), Edinburgh.

REFERENCE: Hollstein, vol.26 (1982), p.136, under no.90 [D. de Hoop Scheffer]; Andrews 1985a, vol.1, p.79, vol.2, p.133, fig.520; Wilmers 1996, pp.102–3, under no.A39; Diels 2009, p.239.

The Virgin Mary's coronation is not related in the Bible, nor in the legendary accounts of her life. Derived from medieval homilies and liturgy, the subject has occurred regularly in religious art since the twelfth century. The iconography Schut chose is a conflation of the coronation with the ascension of Saint Mary, blended with the gathering of all the saints in Heaven.

Schut repeatedly made etchings after his own paintings, a practice that was inspired by Rubens's enterprise of reproductive engravings, albeit in a different technique and an entirely different, much looser graphic style. The present sheet offers a rare and fascinating glimpse into the artist's working process.[2] Around 1639–40, Schut had executed The Coronation of the Virgin with Saints, a prestigious commission for the high altarpiece for the Jesuit Church in Antwerp.[3] His drawing in Amsterdam is a faithful copy of his large painting and a preparatory study for the etching (fig.42). It is incised and the reverse blackened, indicating that Schut used it to transfer the composition onto the etching copperplate. He then pulled a proof impression and, putting the wet print onto another sheet of paper and rubbing its reverse, created a counterproof in the same orientation as his drawing (and the painting). Schut worked up this counterproof with pen and ink, in particular refining the distribution of light and shade. Afterwards, he amended the copperplate accordingly and pulled a first edition (fig.43), reworking the plate with the burin to once more strengthen the dark areas before printing another edition. Only in the final state of the copperplate was an inscription added, which included the names of Schut and the Antwerp publisher Franciscus van den Wijngaerde.[4]

1. According to Andrews (p.79) not identifiable in his sale, London (Phillips), 26 January 1804 [L.6733]. I have been unable to consult a copy of this sale catalogue. It was not in M'Gowan's sale of prints, London (T. Philipe & Scott), 13 May 1803 [L.6631].
2. On Schut's etchings see Luijten 2006 and Diels 2009, pp.88–204, 207–41.
3. Saint Carlo Borromeo Church, Antwerp; Wilmers 1996, no.A39, fig. A39.
4. The states given in Hollstein can be amended: I. the present sheet (worked up counterproof of a state not described in Hollstein and preceding his state 1); II. Hollstein I (a counterproof of this state is in the Graphische Sammlung, Munich, inv. 33615 D); III. Hollstein II; IV. Hollstein III.

Fig.42 | Cornelis Schut, The Coronation of the Virgin with Saints, c.1639–40, pen and brown and black ink over black chalk, 394 × 293 mm
Rijksmuseum, Amsterdam (RP-T-1980-20)

Fig.43 | Cornelis Schut, The Coronation of the Virgin with Saints, c.1639–40, etching, 395 × 290 mm
Rijksmuseum, Amsterdam (RP-P-OB-59.243)

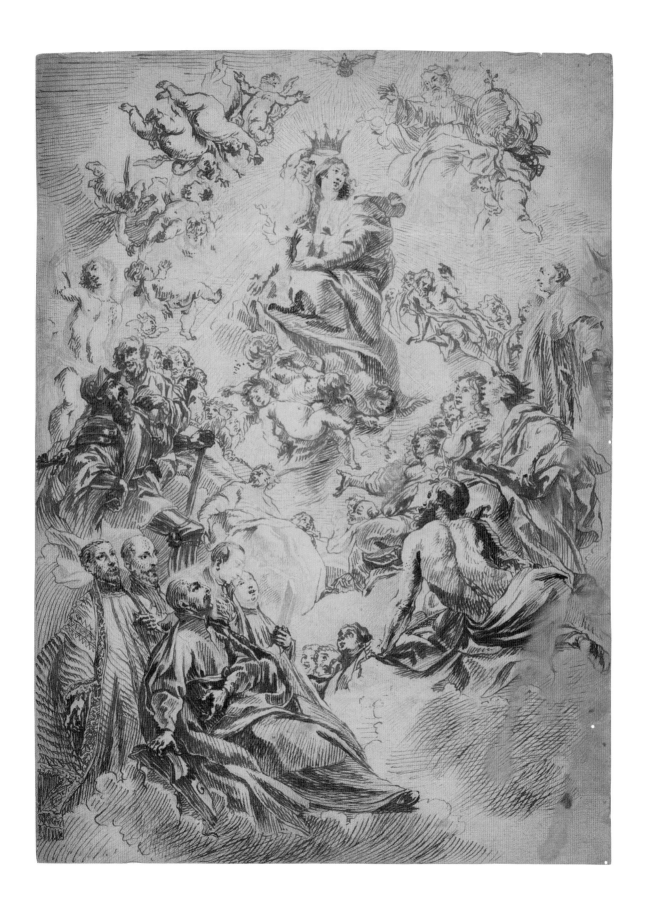

25 · Theodoor van Thulden (1606–1669), after Gerard Seghers (1591–1651), after a design by Peter Paul Rubens (1577–1640)
Philip IV Appointing Prince Ferdinand Governor of the Netherlands, c.1635–42

Oil in black, brown and ochre on paper, 172 × 256 mm (laid down)
Inscription on the mount: 'from M.ʳ Hawinks' (of the Brit. Museum) Collection' (in black ink)
William Findlay Watson Bequest 1881 (D 2861)

PROVENANCE: Probably Edward Hawkins (1780–1867), London; Henry Stephen Olivier (1795–1864), Potterne, Wiltshire [Lugt 1373]; William Findlay Watson (1810–1881), Edinburgh.

REFERENCE: Martin 1972, p.138, under no.35; Andrews 1985a, vol.1, p.87, vol.2, p.152, fig.578.

On 15 May 1635, a few months after the festivities at Ghent (see cat.23), Ferdinand of Austria held his 'Joyous Entry' into Antwerp. Johannes Caspar Gervartius, a humanist scholar and clerk of the city, Nicolaas Rockox, a city councillor and former mayor, and their intimate friend Peter Paul Rubens were entrusted with the programme and the imagery of this enterprise.[1] In close collaboration they devised the subjects and Rubens provided the oil sketches. For the execution of these designs on the huge canvases, Rubens recruited many of the leading painters of the day, among them Jacques (Jacob) Jordaens, Gerard Seghers and Theodoor van

Thulden. As with the entry into Ghent, the festivities and the ephemeral decorations were commemorated in a richly illustrated folio book, *Pompa Introitus Ferdinandi*, published after much delay in 1642.[2] Neither Rubens, who died in 1640, nor Ferdinand, who died the year after, lived to see this great book.

Theodoor van Thulden, who had also been involved in Ghent, was commissioned to produce the etchings. This small brunaille on paper, an oil sketch in different tones of brown and ochre, is a fragment of the preparatory sketch he used for plate 96 and corresponds in size to the engraving (fig.44). It depicts Philip IV appointing his brother Ferdinand Governor of the Southern Netherlands in an allegorical setting, as employed by Schut in his drawing (see cat.23). Van Thulden's sketch is a copy in reverse after the centrepiece of the *Stage of Isabella* (fig.45). A fragment of this large painting, executed by Gerard Seghers after Rubens's oil sketch, has survived.[3] Another of Van Thulden's rare preparatory designs for this series of etchings, *Mercury Departing from Antwerp*, executed in the same technique, was on the art market in 1992.[4]

Fig.44 | Theodoor van Thulden, after Peter Paul Rubens, *Philip IV Appointing Prince Ferdinand Governor of the Netherlands*, 1639–41, etching, 268 × 333 mm
Rijksmuseum, Amsterdam (RP-P-OB-70.265)

Fig.45 | Theodoor van Thulden, after Peter Paul Rubens, *The Stage of Isabella*, 1639–41, etching, 500 × 383 mm
Rijksmuseum, Amsterdam (RP-P-OB-70.264)

1. Martin 1972, pp.23–34; Held 1980, vol.1, pp.221–47; Knaap/Putnam/Arnold-Biucchi 2013.
2. Gervartius 1642.
3. Martin 1972, nos 34a, 35, figs 64 (oil sketch), 65 (fragment), 66 (engraving); Held 1980, no.158, pl.155; Hollstein, vol.30 (1986), pp.127–8, nos 123–4 [G. Luijten].
4. Oil in brown and yellow, on brown paper, 286 × 255 mm, sale Hans van Leeuwen, Amsterdam (Christie's), 24 November 1992, lot 187; for the lost painting and Van Thulden's print see Martin 1972, no.47, fig.96 (print) and Held 1980, no.162, pl.163; Hollstein, vol.30 (1986), p.132, no.133 [G. Luijten].

26 · Attributed to Frans Wouters (1612–1659), after Titian (c.1485/90–1576)
Diana and Actaeon, c.1634–5

Oil on paper, stuck on panel, 365 × 378 mm (paper),
384 × 394 mm (panel)
Bequeathed by George Watson through the Art Fund 2015
(NG 2875)

PROVENANCE: Sale London (Robinson, Fisher & Harding),
19 November 1936; Clifford Duits (1909–1968), London; from
whom acquired by Henry Lascelles, 6th Earl of Harewood (1882–
1947), 1937[1]; his wife, Mary, The Princess Royal and Countess of
Harewood (1897–1965); her sale London (Christie's), 8 July 1977,
lot 12; where purchased by Alan Jacobs (born 1929), London;
from whom acquired by George G. Watson (1927–2013),
Cambridge, on 6 January 1978.

REFERENCE: Wethey 1975, p.141; Pignatti 1993, pp.75, 78, 82,
note 9 (no.9), fig.8; Rearick 1996, p.48.

EXHIBITED: London 1972b, no.38.

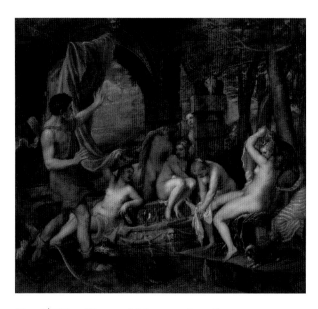

Fig.46 | Titian, *Diana and Actaeon*, 1556–9, oil on canvas,
184.5 × 202.2 cm
Purchased jointly by the National Galleries of Scotland and the National
Gallery, London, with contributions from The Scottish Government, the
National Heritage Memorial Fund, The Monument Trust, the Art Fund
(with a contribution from the Wolfson Foundation), Artemis Investment
Management Ltd, Binks Trust, Mr Busson on behalf of EIM Group,
Dunard Fund, The Fuserna Foundation, Gordon Getty, The Hintze Family
Charitable Foundation, J. Paul Getty Jnr Charitable Trust, John Dodd,
Northwood Charitable Trust, The Rothschild Foundation, Sir Siegmund
Warburg's Voluntary Settlement and through public appeal 2009 (NG 2839)

The ancient Roman poet Ovid tells the mythological
story of Diana and Actaeon in his *Metamorphoses*
(III:138–253). By mistake Actaeon entered a cave sacred
to Diana, the chaste goddess of hunting, where she was
bathing with her nymphs. Furious at being discovered
naked, she transformed the young huntsman into a stag,
whereupon he was chased by his own dogs and torn to
pieces.

The prototype for this oil sketch is Titian's painting of
1556–9 (fig.46). Painted for Philip II it remained in the
Spanish royal collection until 1704.[2] The present sketch
was recently acquired through the Art Fund with an
attribution to David Teniers the Younger. Teniers indeed
painted a large number of small copies, so-called 'pas-
ticci', after Italian paintings in the collection of Archduke
Leopold Wilhelm in Brussels. They served as models
for the *Theatrum Pictorium*, a catalogue of the collection
illustrated with 243 engravings, published in 1660.[3]
However, Teniers never visited Madrid and could not
have seen Titian's work, nor does it (or a copy thereafter)
feature in the *Theatrum Pictorium*. Although the present
sketch was in the Harewood Collection, which contained
thirty-seven 'pasticci', it did not belong to the group of
120 that had stayed together since Teniers's days and had
been in the Marlborough Collection from before 1722
until their dispersal at auction in 1886.[4] Moreover, the
sketch is larger than Teniers's and painted on paper that
was stuck onto a modern panel, probably as late as the
twentieth century, while Teniers used panel supports and
occasionally canvas.[5] Finally, the execution is less refined
than his 'pasticci' commonly are.[6]

Instead, an attribution of *Diana and Actaeon* to Frans
Wouters, who worked in Rubens's studio in 1634–5,
seems plausible.[7] Compare, for example, Wouters's
Andromeda, one of the few secure works by the artist
(fig.47).[8] The facial type and execution of the hair and
foliage are very similar, as is a detail such as the elon-
gated toes. Wouters's sketch after Titian's *Diana and
Actaeon* is faithful overall but shows several liberties

which a copyist would not usually take: the group of trees on the right is lighter, with less foliage; the dress of Diana's servant has been simplified and the colour changed; and Actaeon's quiver has a triangular (instead of round) shape with an unadorned strap, and the fluttering end of his garment is broader. Therefore the sketch could be a copy after one of the two versions by Titian that were lost without leaving any visual record: one offered to Emperor Maximilian II in 1568 and another that was in Rubens's collection from 1622 to 1626, then in the Duke of Buckingham's, and back in Antwerp in 1648.[9] There is, however, yet another, more likely candidate for the prototype of Wouters's sketch: Rubens's full-scale copy after Titian's *Diana and Actaeon*, made in Spain in 1628–9, sold from Rubens's estate between 1640 and 1645, and now lost.[10] Rubens copied Titian's pendant *Diana and Callisto* (Scottish National Gallery, Edinburgh and National Gallery, London) on the same occasion.[11] Wouters painted a sketch – very similar to the Gallery's one and of almost the same dimensions – of this picture, too (fig.48).[12] It is tempting to link these two copies to 'two paintings by Wouters of Diana after Rubens' that were sold in Antwerp in 1646.[13] Wouters used some motifs of Titian's *Diana and Actaeon*, known to him through Rubens's copy, for his own painting of this subject.[14]

1. Provenance information until 1937 kindly provided by Margret Klinge. I have been unable to trace a copy of the 1936 sale catalogue.
2. Edinburgh 2004, no.54.
3. London 2006.
4. On the provenance of the 'pasticci' see Methuen-Campbell 2006.
5. Technical examination on 26 January 2016; with thanks to Jacqueline Ridge, Lesley Stevenson and Graeme Gollan.
6. Margret Klinge and Hans Vlieghe have both rejected the attribution to Teniers (emails 4 May 2015 and 23 March 2016).
7. Tentatively suggested by Hans Vlieghe (email 23 March 2016).
8. Kemmer 1995, pp.206–7, 233–5, fig.5. He dates the *Andromeda* to the 1640s.
9. On the copies see Wethey 1975, pp.140–1 and Pignatti 1993. Rearick 1996, p.66, note 79 claimed that the Gallery's sketch was executed after what he and Pignatti regarded as Titian's 'ricordo' (his p.51, fig.23). However, this picture differs – like Titian's *Diana and Actaeon* and all copies of which I have been able to see images – in all the above-mentioned elements from the sketch. On Buckingham's version see Muller 1989, p.149, no.9, on Wouters's involvement in the sale of Buckingham's collection see Hairs 1977, p.48.
10. Muller 1989, p.104, no.44.
11. Inv. NG 2844; Wood 2010b, no.121, fig.64. For Rubens's drawing with studies after both paintings by Titian see New York 2005, no.7, ill.
12. Last offered at the sale Vienna (Dorotheum), 11 June 2003, lot 128, ill. (as attributed to Frans Wouters; bought in).
13. 'Twee stucken van Diana geschildert van Wouters near Rubbens ende noch een stuck van Ryckhals tsamen tot fl.300'; Duverger 1984–2009, vol.5 (1991), pp.328–9. The relatively high price may indicate larger paintings for which the two sketches may have been preparatory. One of the latter may be identified with 'a small painting of the Bath of Diana by Wouters' ('een stucxsken een Badt van Diana van Wouters') sold in Antwerp in 1666; idem, vol.9 (1997), pp.34–5.
14. Oil on panel, 61 × 74.9 cm, present whereabouts unknown (sale London (Christie's), 26 June 1964, lot 128, ill.). The same painting sold in London (Christie's), 10 November 1967, lot 117 (Gns500, to West) and was withdrawn from the sale London (Christie's) 26 July 1968, lot 133.

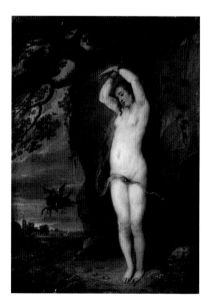

Fig.47 | Frans Wouters, *Andromeda*, c.1635–45, oil on canvas, 38 × 27 cm
Musée des Beaux-Arts, Nancy (118)

Fig.48 | Attributed to Frans Wouters, after Titan, *Diana and Callisto*, c.1634–5, oil on panel, 37.5 × 40.5 cm
Present whereabouts unknown

Bibliography

ADLER 1982 W. Adler, *Rubens: Landscapes and Hunting Scenes* (CRLB XVIII, 1), London/New York, 1982

ALSTEENS 2016 S. Alsteens, 'A portraitist's progress', in New York 2016, pp.1–37

AMSTERDAM 1995 J. Huisken, K. Ottenheym and G. Schwartz (eds), *Jacob van Campen: Het klassieke ideaal in de Gouden Eeuw*, exh. cat., Amsterdam (Koninklijk Paleis), 1995

ANDREWS 1961 K. Andrews, *Fifty Master Drawings in the National Gallery of Scotland*, Edinburgh, 1961

ANDREWS 1971 K. Andrews, *National Gallery of Scotland: Catalogue of Italian Drawings*, 2 vols, Edinburgh, 1971

ANDREWS 1985A K. Andrews, *Catalogue of Netherlandish Drawings in the National Gallery of Scotland*, 2 vols, Edinburgh, 1985

ANDREWS 1985B K. Andrews, 'An early Rubens drawing', *The Burlington Magazine* 127 (1985), pp.526, 528–31

ANTWERP 1949 *Van Dyck Tentoonstelling*, exh. cat., Antwerp (Koninklijk Museum voor Schone Kunsten), 1949

ANTWERP 1954 *La Madone dans l'Art*, exh. cat., Antwerp (Koninklijk Museum voor Schone Kunsten), 1954

ANTWERP 1956 L. Burchard and R.-A. d'Hulst, *Tekeningen van P. P. Rubens*, exh. cat., Antwerp (Rubenshuis), 1956

ANTWERP 1993 R.-A. d'Hulst, N. de Poorter and M. Vandenven, *Jacob Jordaens (1593–1678)*, 2 vols, exh. cat., Antwerp (Koninklijk Museum voor Schone Kunsten), 1993

ANTWERP/MÜNSTER 1990 J. Luckhardt and H. Vlieghe, *Jan Boeckhorst 1604–1668: Maler der Rubenszeit*, exh. cat., Antwerp (Rubenshuis)/Münster (Westfälisches Landesmuseum für Kunst und Kulturgeschichte), 1990

ANTWERP/ROTTERDAM 1960 R.-A. d'Hulst and H. Vey, *Antoon van Dyck: Tekeningen en olieverfschetsen*, exh. cat., Antwerp (Rubenshuis)/Rotterdam (Museum Boijmans Van Beuningen), 1960

ANTWERP/ROTTERDAM 1966 R.-A. d'Hulst, *Tekeningen van Jacob Jordaens 1593–1678*, exh. cat., Antwerp (Rubenshuis)/Rotterdam (Museum Boijmans Van Beuningen), 1966–7

BALIS 1993 A. Balis, '"Fatto da un mio discepolo": Rubens's studio practices reviewed', in T. Nakamura (ed.), *Rubens and his Workshop: The Flight of Lot and his Family from Sodom*, exh. cat., Tokyo (National Museum of Western Art), 1993, pp.97–127

BALIS 2007 A. Balis, 'Rubens and his studio: defining the problem', in Brussels 2007, pp.30–51

BARNES ET AL. 2004 S. Barnes, N. De Poorter, O. Millar and H. Vey, *Van Dyck: A Complete Catalogue of the Paintings*, New Haven/London, 2004

BASKETT/DAY 1987 R. Day, *An Exhibition of Old Master Drawings (Richard Day Ltd)*, New York/London, 1987

BECANUS 1636 G. Becanus, *Serenissimi principis Ferdinandi Hispaniarum Infantis S.R.E. Cardinalis introitus in Flandriae metropolim Gandavum*, Antwerp: Johannes Meursius, 1636

BECK 1981 H.U. Beck, 'Anmerkungen zu den Zeichnungssammlungen von Valerius Röver und Goll van Franckenstein', *Nederlands Kunsthistorisch Jaarboek* 32 (1981), pp.111–26

BÉGUIN 1991 S. Béguin, 'Theodoor van Thulden en de kunst van Fontainebleau/Théodore van Thulden et l'art de Fontainebleau', in 's-Hertogenbosch/Strasbourg 1991, pp.99–110

BÉGUIN/GUILLAUME/ROY 1985 S. Béguin, J. Guillaume and A. Roy, *La galerie d'Ulysse à Fontainebleau*, Paris, 1985

BELKIN 1977 K. Belkin, *Rubens: The Costume Book* (CRLB XXIV), London, 1977

BELKIN 1998 K. Lohse Belkin, *Rubens (Phaidon Art & Ideas)*, London, 1998

BELKIN 2009 K. Lohse Belkin, *Rubens: Copies and Adaptations from Renaissance and Later Artists* (CRLB XXVI, 1): *German and Netherlandish Artists*, 2 vols, London/Turnhout, 2009

BONN 2015 [G. Satzinger and S. Schütze], *Der Göttliche: Hommage an Michelangelo*, exh. cat., Bonn (Kunst- und Ausstellungshalle der Bundesrepublik Deutschland), 2015

BROOKVILLE 1986 G.S. Davidson, *Drawing the Fine Line: Discovering European Drawings in Long Island Private Collections*, exh. cat., Brookville (Long Island University), 1986

BRUSSELS 1965 *De Eeuw van Rubens*, exh. cat., Brussels (Koninklijke Musea voor Schone Kunsten), 1965

BRUSSELS 2007 J. Vander Auwera and S. van Sprang (eds), *Rubens: A Genius at Work*, exh. cat., Brussels (Royal Museums of Fine Arts), 2007–8

BRUSSELS/KASSEL 2012 J. Vander Auwera and I. Schaudies (eds), *Jordaens and the Antique*, exh. cat., Brussels (Royal Museums of Fine Arts)/Kassel (Gemäldegalerie Alte Meister), 2012–13

BRUSSELS/PARIS 1949 [J.C. Ebbinge Wubben], *De Van Eyck à Rubens: Les Maîtres Flamands du Dessins*, exh. cat., Brussels (Palais des Beaux-Arts)/Paris (Bibliothèque Nationale), 1949

BRYANT 2003 J. Bryant, *Kenwood: Paintings in the Iveagh Bequest*, New Haven/London, 2003

BURCHARD/D'HULST 1963 L. Burchard and R.-A. d'Hulst, *Rubens Drawings*, 2 vols, Brussels, 1963

CATS 1632 J. Cats, *Spiegel Van den Ouden ende Nieuwen Tijdt*, The Hague: Isaac Burchoorn, 1632

LE CLAIRE 1996 T. le Claire, *Woman Observed (Thomas le Claire Kunsthandel X)*, Hamburg/New York, 1996

LE CLAIRE 1998 T. le Claire, *Master Drawings 1500–1900 (Thomas le Claire Kunsthandel XI)*, Hamburg/New York, 1998

COLE 1993 W. Cole, *A Catalogue of Netherlandish and North European Roundels in Britain (Corpus Vitrearum Medii Aevi: Great Britain, Summary Catalogue 1)*, Oxford, 1993

COLOGNE 1977 J. Müller Hofstede (ed.), *Peter Paul Rubens 1577–1640: Katalog I. Rubens in Italien*, exh. cat., Cologne (Wallraf-Richartz-Museum), 1977

CRLB *Corpus Rubenianum Ludwig Burchard: an illustrated catalogue raisonné of the work of Peter Paul Rubens based on the material assembled by the late Ludwig Burchard*, London, 1968–

DEVISSCHER/VLIEGHE 2014 H. Devisscher and H. Vlieghe, *Rubens: The Life of Christ before the Passion. The Youth of Christ (CRLB V, 1)*, 2 vols, London, 2014

DÍAZ PADRÓN 2012 M. Díaz Padrón, *Van Dyck en España*, 2 vols, Barcelona, 2012

DIELS 2009 A. Diels, *The Shadow of Rubens: Print Publishing in 17th-century Antwerp*, London/Turnhout, 2009

DODGSON 1913 C. Dodgson, 'J. Jordaens: illustration of a Flemish proverb', *Vasari Society* 8 (1912–13), no. 23

DUVERGER 1984–2009 E. Duverger, *Antwerpse kunstinventarissen uit de zeventiende eeuw (Fontes historiae artis Neerlandicae 1)*, 14 vols, Brussels, 1984–2009

DUVERGER 1995 E. Duverger, 'De Antwerpse graveur Jan Baptist Barbé en Pieter Paul Rubens', *Gentse bijdragen tot de kunstgeschiedenis en oudheidkunde* 30 (1995), pp.224–7

VAN DUYSE 1844 P. Van Duyse, *Boekbeschryving. Wat een boek met twee-en-veertig platen in groot folio eertyds kostte*, Ghent, 1844

EDINBURGH 1963 C. Thompson and R. Hutchison, *Allan Ramsay (1713–1784): His Masters and Rivals*, exh. cat., Edinburgh (National Gallery of Scotland), 1963

EDINBURGH 1976 K. Andrews, *Old Master Drawings from the David Laing Bequest*, exh. cat., Edinburgh (National Gallery of Scotland), 1976

EDINBURGH 1981 K. Andrews, *Drawings from the Bequest of W.F. Watson 1881–1981*, exh. cat., Edinburgh (National Gallery of Scotland), 1981

EDINBURGH 1993 *From Brueghel to Rubens: Flemish Drawings from the National Gallery of Scotland*, exhibition, Edinburgh (National Gallery of Scotland), 1993 [no publication]

EDINBURGH 1999 M. Clarke *et al.*, *The Draughtsman's Art: Master Drawings from the National Gallery of Scotland*, exh. cat., Edinburgh (National Gallery of Scotland)/New York (The Frick Collection)/Houston (Museum of Fine Arts), 1999–2001

EDINBURGH 2001 M. Clarke *et al.*, *From the Madonna to the Moulin Rouge: Drawings Recently Acquired for the National Gallery of Scotland*, exh. cat., Edinburgh (National Gallery of Scotland), 2001

EDINBURGH 2004 P. Humfrey, T. Clifford, A. Weston-Lewis and M. Bury, *The Age of Titian: Venetian Renaissance Art from Scottish Collections*, exh. cat., Edinburgh (National Gallery of Scotland), 2004.

EDINBURGH 2007 *Drawing to an End*, exhibition, Edinburgh (National Gallery of Scotland), 2007 [no publication]

EDINBURGH 2012 *Red Chalk: Raphael to Ramsay*, exhibition, Edinburgh (Scottish National Gallery), 2012 [no publication]

EDINBURGH 2013 T. Bonenkamp, *Drawn by Life. Dutch and Flemish Drawings from the Seventeenth Century*, exh. cat., Edinburgh (Scottish National Gallery), 2013, https://www.nationalgalleries.org/media/_file/education/Drawn_by_Life1.pdf (accessed 25 March 2016)

EDINBURGH/LONDON 1985 [K. Andrews], *Some Netherlandish Drawings from the National Gallery of Scotland*, exh. leaflet, Edinburgh (National Gallery of Scotland)/London (Hazlitt, Gooden & Fox Ltd), 1985–6

EDINBURGH/LONDON 1994 [T. Clifford *et al.*], *From Leonardo to Manet: Ten Years of Collecting Prints and Drawings*, exh. cat., Edinburgh (National Gallery of Scotland)/London (Hazlitt, Gooden & Fox Ltd), 1994

EDINBURGH/LONDON 1995 S. Lloyd, *Richard & Maria Cosway: Regency Artists of Taste and Fashion*, exh. cat., Edinburgh (Scottish National Portrait Gallery)/London (National Portrait Gallery), 1995–6

EDINBURGH/NOTTINGHAM 2002 J. Wood, *Rubens: Drawing on Italy*, exh. cat., Edinburgh (National Gallery of Scotland)/Nottingham (Djanogly Art Gallery), 2002

FOUCART 1979 J. Foucart, 'Postface à l'exposition "Le siècle de Rubens dans les collections publiques françaises"', *Revue du Louvre* 29 (1979), pp.151–7

GALEN 2012 M. Galen, *Johann Boeckhorst: Gemälde und Zeichnungen*, Hamburg, 2012

GERVARTIUS 1642 J.C. Gevartius, *Pompa introitus Ferdinandi Austriaci Hispaniarum Infantis [...]*, Antwerp: Johannes Meursius, 1642

GILTAIJ 2000 J. Giltaij, *Honderdvijftig jaar er bij en er af: De Collectie Oude Schilderkunst van het Museum Boijmans Van Beuningen Rotterdam 1849 tot 1999*, Zutphen, 2000

GONZÁLEZ DE AMEZUA ET AL. 2004 R. González de Amezua *et al.*, *Real Academia de San Fernando Madrid: Guía del museo*, Madrid, 2004

GREENWICH/CINCINNATI/BERKELEY 2004 P.C. Sutton and M.E. Wieseman, *Drawn by the Brush: Oil Sketches by Peter Paul Rubens*, Greenwich (Bruce Museum of Arts and Science)/Cincinnati (Cincinnati Art Museum)/Berkeley (University of California, Berkeley Art Museum and Pacific Film Archive), 2004–5

GROSVENOR 2014 B. Grosvenor, 'A new Van Dyck attribution at the Scottish National Gallery', in *Art History News* (23 October 2014), http://arthistorynews.com/articles/3051 (accessed 20 February 2016)

HAIRS 1977 Marie-Louise Hairs, *Dans le sillage de Rubens: les peintres d'histoire Anversois au XVIIe siècle*, Liège, 1977

HAVERKAMP-BEGEMANN 1969 E. Haverkamp-Begemann, 'Jacob Jordaens at the National Gallery of Canada', *Master Drawings* 7 (1969), pp.173–8

HEAWOOD E. Heawood, *Watermarks. Mainly of the 17th and 18th Centuries (Monumenta Chartæ Papyriceæ 1)*, Hilversum, 1950

HELD 1959 J.S. Held, *Rubens: Selected Drawings*, 2 vols, London, 1959

HELD 1969 J.S. Held, 'Jordaens at Ottawa', *The Burlington Magazine* 111 (1969), pp.265–73

HELD 1972 J.S. Held, 'Rubens and the Vita Beati P. Ignatii Loiolae of 1609', in J.R. Martin (ed.), *Rubens before 1620*, Princeton, 1972, pp.93–134

HELD 1974 J.S. Held, 'Some Rubens drawings: unknown or neglected', *Master Drawings* 12 (1974), pp.249–60, 320–6

HELD 1980 J.S. Held, *The Oil Sketches of Peter Paul Rubens: A Critical Catalogue*, 2 vols, Princeton, 1980

HELD 1984 J.S. Held, 'Ursula König-Nordhoff, Ignatius van Loyola: Studien zur Entwicklung einer neuen Heiligen-Ikonographie im Rahmen einer Kanonisationskampagne um 1600', *Kunstchronik* 37 (1984), pp.46–53

HELD 1985A J.S. Held, 'Nachträge zum Werk des Johann Bockhorst (alias Jan Boeckhorst)', *Westfalen* 63 (1985), pp.14–37

HELD 1985B J.S. Held, 'Some studies of heads by Flemish and Dutch seventeenth-century artists', *Master Drawings* 23–24 (1985–6), pp.46–53, 129–140

HELD 1986 J.S. Held, *Rubens: Selected Drawings* (revised edition), Oxford, 1986

'S-HERTOGENBOSCH 2000 P. Huys Janssen (ed.), *Meesters van het zuiden: Barokschilders rondom Rubens*, exh. cat., 's-Hertogenbosch (Noordbrabants Museum), 2000

'S-HERTOGENBOSCH/STRASBOURG 1991 A. Roy (ed.), *Theodoor van Thulden: Een Zuidnederlandse barokschilder/Un peintre baroque du cercle de Rubens*, exh. cat., 's-Hertogenbosch (Noordbrabants Museum)/Strasbourg (Musées de la ville de Strasbourg), 1991–2

HOLLSTEIN F.W.H. Hollstein, *Dutch and Flemish Etchings, Engravings and Woodcuts, ca. 1450–1700*, 72 vols, Amsterdam *et al.*, 1949–2010

HOWARTH 2003 D. Howarth, 'Reviews of exhibitions', *Renaissance Studies* 17 (2003), pp.114–21

D'HULST 1953 R.-A. d'Hulst, 'De tekeningen van Jacob Jordaens in het Museum Boymans II', *Bulletin Museum Boymans* 4 (1953), pp.73–81

D'HULST 1956 R.-A. d'Hulst, *De tekeningen van Jakob Jordaens: Bijdrage tot de geschiedenis van de XVIIe-eeuwse kunst in de zuidelijke Nederlanden*, Brussels, 1956

D'HULST 1957 R.-A. d'Hulst, 'Nieuwe gegevens omtrent enkele tekeningen van Jacob Jordaens', *Gentse Bijdragen tot de Kunstgeschiedenis en de Oudheidkunde* 17 (1957–1958), pp.135–55

D'HULST 1969 R.-A. d'Hulst, 'Jordaens', *Art Bulletin* 51 (1969), pp.378–88

D'HULST 1974 R.-A. d'Hulst, *Jordaens Drawings*, 4 vols, London/New York, 1974

D'HULST 1982 R.-A. d'Hulst, *Jacob Jordaens*, London, 1982

D'HULST/DE POORTER 1993 R.-A. d'Hulst and N. de Poorter, 'Chronology', in Antwerp 1993, vol.1, pp.7–21

D'HULST/VANDENVEN 1989 R.-A. d'Hulst and M. Vandenven, *Rubens: The Old Testament (CRLB III)*, London, 1989

JAFFÉ 1966A M. Jaffé, 'Jordaens drawings at Antwerp and Rotterdam', *The Burlington Magazine* 108 (1966), pp.625–30

JAFFÉ 1966B M. Jaffé, 'Rubens as a collector of drawings: part three', *Master Drawings* 4 (1966), pp.127–48, 188–203

JAFFÉ 1967 M. Jaffé, 'Rubens and Raphael', in J. Courtauld (ed.), *Studies in Renaissance and Baroque Art presented to Anthony Blunt on his 60th Birthday*, London, 1967, pp.98–107

JAFFÉ 1970 M. Jaffé, 'A sheet of drawings from Rubens' Italian period', *Master Drawings* 8 (1970), pp.42–51, 103–4

JAFFÉ 1971 M. Jaffé, 'Figure drawings attributed to Rubens, Jordaens, and Cossiers in the Hamburger Kunsthalle', *Jahrbuch der Hamburger Kunstsammlungen* 16 (1971), pp.39–50

JAFFÉ 1977 M. Jaffé, *Rubens and Italy*, Oxford, 1977

JAFFÉ 2002 M. Jaffé, 'Edinburgh and Nottingham: Rubens and Italy', *The Burlington Magazine* 144 (2002), pp.643–5

JUDSON/VAN DE VELDE 1978 J.R. Judson and C. Van de Velde, *Rubens: Book Illustrations and Title-Pages (CRLB XXI)*, 2 vols, London/Philadelphia, 1978

KEMMER 1995 C. Kemmer, 'Betrachtungen zum Werk von Frans Wouters, insbesondere zu seinem Gemälde "Jupiter und Callisto"', *Jaarboek van het Koninklijke Museum voor Schone Kunsten Antwerpen* 1995, pp.195–241

KNAAP/PUTNAM/ARNOLD-BIUCCHI 2013 A.C. Knaap, M.C.J. Putnam and C. Arnold-Biucchi (eds), *Art, Music and Spectacle in the Age of Rubens: The Pompa Introitus Ferdinandi*, London, 2013

KÖNIG-NORDHOFF 1976 U. König-Nordhoff, 'Zur Entstehungsgeschichte der Vita Beati P. Ignatii Loiolae Societatis Iesu Fundatoris Romae 1609 und 1622', *Archivum Historicum Societatis Iesu* 45 (1976), pp.306–317

KÖNIG-NORDHOFF 1982 U. König-Nordhoff, *Ignatius von Loyola: Studien zur Entwicklung einer neuen Heiligen-Ikonographie im Rahmen einer Kanonisationskampagne um 1600*, Berlin, 1982

KOPECKY 2012 V. Kopecky, *Die Beischriften des Peter Paul Rubens: Überlegungen zu handschriftlichen Vermerken auf Zeichnungen*, PhD dissertation Hamburg (Universität Hamburg), 2008/London, 2012, http://ediss.sub.uni-hamburg.de/volltexte/2012/5813/ (accessed 25 March 2016)

KUZNETSOV 1974 Y. Kuznetsov, *Risunki Rubensa*, Moscow, 1974

L. F. Lugt, *Répertoire des catalogues de ventes publiques intéressant l'art ou la curiosité*, 4 vols, The Hague, 1938–87

LAHRKAMP 1982 H. Lahrkamp, 'Der "Lange Jan": Leben und Werk des Barockmalers Johann Bockhorst aus Münster', *Westfalen* 60 (1982), pp.3–183

LAMMERTSE/VERGARA 2012 F. Lammertse and A. Vergara, 'A portrait of Van Dyck as a young artist', in id., *The Young Van Dyck*, exh. cat., Madrid (Museo del Prado), 2012–13

LARSEN 1988 E. Larsen, *The Paintings of Anthony van Dyck*, 2 vols, Freren, 1988

LEESBERG 2012 M. Leesberg, *Hendrick Goltzius (The New Hollstein Dutch & Flemish Etchings, Engravings and Woodcuts 1450–1700)*, 4 vols, Oudekerk aan den Ijssel, 2012

LEICESTER 1952 P.A. Tomory, *Old Master Drawings*, Leicester (Leicester Museum & Art Gallery), 1952

LOGAN 1978 A.-M. Logan, 'Rubens exhibitions 1978–1979', *Master Drawings* 16 (1978), pp.419–50

LOGAN 1983 A.-M. Logan, 'Julius S. Held, The oil sketches of Peter Paul Rubens: a critical catalogue', *Master Drawings* (1983), pp.412–17

LOGAN 1987 A.-M. Logan, 'Julius S. Held, Rubens: selected drawings', *Master Drawings* 25 (1987), pp.63–82

LOGAN 1991 A.-M. Logan, 'Publications received', *Master Drawings* 29 (1991), pp.315–17

LONDON 1927 *Exhibition of Flemish and Belgian Art: 1300 to 1900*, exh. cat., London (Royal Academy of Arts), 1927

LONDON 1938 *Catalogue of the Exhibition of 17th-Century Art in Europe*, exh. cat., London (Royal Academy of Arts), 1938

LONDON 1953A *Drawings by Old Masters*, exh. cat., London (Royal Academy of Arts), 1953

LONDON 1953B *Flemish Art 1300–1700*, exh. cat., London (Royal Academy of Arts), 1953–4

LONDON 1966 [K. Andrews], *Old Master Drawings: A Loan Exhibition from the National Gallery of Scotland*, exh. cat., London (Colnaghi's), 1966

LONDON 1972A O. Millar, *The Age of Charles I: Painting in England 1620–1649*, exh. cat., London (Tate Gallery), 1972–3

LONDON 1972B L.S., *Cabinet Pictures by David Teniers* [on long-term loan from the Executors of the late Princess Royal], exh. leaflet, Kenwood House, London, 1972

LONDON 1977 J. Rowlands, *Rubens: Drawings and Sketches*, exh. cat., London (British Museum), 1977

LONDON 1981 D. Chambers and J. Martineau, *Splendours of the Gonzaga*, exh. cat., London (Victoria & Albert Museum), 1981–2

LONDON 1982A O. Millar, *Van Dyck in England*, exh. cat., London (National Portrait Gallery), 1982–3

LONDON 1982B C. Whitfield and J. Martineau, *Painting in Naples 1606–1705: From Caravaggio to Giordano*, exh. cat., London (Royal Academy of Arts), 1982

LONDON 1996 C. Brown, *Rubens's Landscapes: Making and Meaning*, exh. cat., London (National Gallery), 1996–7

LONDON 2005 D. Jaffé *et al.*, *Rubens: A Master in the Making*, exh. cat., London (National Gallery), 2005–6

LONDON 2006 E. Vegelin van Claerbergen (ed.), *David Teniers and the Theatre of Painting*, exh. cat., London (The Courtauld Gallery), 2006–7

LONDON 2009 K. Hearn (ed.), *Van Dyck & Britain*, exh. cat., London (Tate Britain), 2009

LONDON 2010 *Nicholas Lanier 1588–1666: A Portrait Revealed*, exh. cat., London (Weiss Gallery), 2010

LUGT F. Lugt, *Les Marques de Collections de Dessins & d'Estampes*, 2 vols, Amsterdam, 1921/The Hague, 1956,

www.marquesdecollections.fr (accessed 25 March 2016)

LUIJTEN 2006 G. Luijten, 'Het Prentwerk van Cornelis Schut', in H. Pauwels (ed.), *Liber Memorialis Erik Duverger: Bijdragen tot de Kunstgeschiedenis van de Nederlanden*, Wetteren, 2006, pp.131–52

MCGRATH 1997 E. McGrath, *Rubens: Subjects from History (CRLB XIII, I)*, 2 vols, London, 1997

MCGRATH 2005 E. McGrath, 'Words and thoughts in Rubens's early drawings', in London 2005, pp.29–37

MARIETTE 1858–9 P.J. Mariette, *Abécédario de P. J. Mariette et autres notes inédites de cet amateur sur les arts et les artistes (Archives de l'Art Français, vol. 10)*, Paris, 1858–9

MARTIN 1968 J.R. Martin, *Rubens: The Ceiling Paintings for the Jesuit Church in Antwerp (CRLB I)*, London/New York, 1968

MARTIN 1972 J.R. Martin, *Rubens: The Decorations for the Pompa Introitus Ferdinandi (CRLB XVI)*, London/New York, 1972

METHUEN-CAMPBELL 2006 J. Methuen-Campbell, 'Early collections of Teniers's copies for the "Theatrum Pictorium"', in London 2006, pp.59–63

MONTREAL 1992 P. Théberge, *The Genius of the Sculptor in Michelangelo's Work*, exh. cat., Montreal (The Montreal Museum of Fine Arts), 1992

MOUSSALLI 1956 U. Moussalli, 'Un chef-d'œuvre inconnu: Les douze signes du zodiaque de Jacques Jordaens', *Le Jardin des Arts* 23 (1956), pp.660–7

MULLER 1989 J. Muller, *Rubens: The Artist as Collector*, Princeton, 1989

MÜNCH/PATAKI 2012 B.U. Münch and Z.Á. Pataki (eds), *Jordaens: Genius of Grand Scale*, Stuttgart, 2012

MUNICH 1997 R. Baumstark (ed.), *Rom in Bayern: Kunst und Spiritualität der ersten Jesuiten*, exh. cat., Munich (Bayerisches Nationalmuseum), 1997

NELSON 1985 K. Nelson, 'Jacob Jordaens' drawings for tapestry', *Master Drawings* 23–24 (1985–6), pp.214–28, 288–301

NELSON 1989 K. Nelson, 'Jacob Jordaens: family portraits', *Leids Kunsthistorisch Jaarboek* 8 (1989), pp.105–19

NELSON 1998 K. Nelson, *Jacob Jordaens: Design for Tapestry*, Turnhout, 1998

NEW YORK 1988 E. Haverkamp-Begemann and C. Logan, *Creative Copies: Interpretative Drawings from Michelangelo to Picasso*, exh. cat., New York (The Drawing Center), 1988

NEW YORK 2005 A.-M. Logan and M.C. Plomp, *Peter Paul Rubens: The Drawings*, exh. cat., New York (The Metropolitan Museum of Art), 2005

NEW YORK 2014 M. Clarke (ed.), *Masterpieces from the Scottish National Gallery*, exh. cat., New York (The Frick Collection), 2014–15

NEW YORK 2016 S. Alsteens and A. Eaker, *Van Dyck: The Anatomy of Portraiture*, exh. cat., New York (The Frick Collection), 2016

NGS 1912 *Catalogue of the National Gallery of Scotland*, Edinburgh, 1912

NGS 1914 *Catalogue of the National Gallery of Scotland*, Edinburgh, 1914

NGS 1919 *Catalogue of the National Gallery of Scotland*, Edinburgh, 1919

NGS 1989 *National Galleries of Scotland: Review 1984–1987*, Edinburgh, 1989

OSTRAND 1975 J.E. Ostrand, *Johann Boeckhorst: His Life and Work*, PhD dissertation Missouri, Columbia (University of Missouri), 1975

OTTAWA 1968 M. Jaffé, *Jacob Jordaens 1593–1678*, exh. cat., Ottawa (National Gallery of Canada), 1968–9

PIGNATTI 1993 T. Pignatti, '"Abozzi" and "Ricordi": new observations on Titian's technique', in J. Manca (ed.), *Titian 500 (Studies in the History of Art 45. Center for Advanced Study in the Visual Arts. Symposium Papers XXV)*, Washington, 1993, pp.73–83

DE PILES 1743 R. de Piles, *The Principles of Painting*, London, 1743

PLOMP 2005 M.C. Plomp, 'Collecting Rubens's drawings', in New York 2005, pp.37–59

PLYMOUTH 2009 S. Smiles (ed.), *Sir Joshua Reynolds: The Acquisition of Genius*, exh. cat., Plymouth (Plymouth City Museum and Art Gallery), 2009

POPE-HENNESSY 1970 J. Pope-Hennessy, *Raphael (The Wrightsman Lectures 4)*, London, 1970

VAN PUYVELDE 1953 L. Van Puyvelde, *Jordaens*, Paris/Brussels, 1953

REARICK 1996 W.R. Rearick, 'Titian's Later Mythologies', *Artibus et Historiae* 17 (1996), pp.23–67

RENGER 1980 K. Renger, 'J. Richard Judson/Carl van de Velde, Rubens: Book illustrations and title-pages (CRLB XXI)', *Zeitschrift für Kunstgeschichte* 43 (1980), pp.429–35

ROSENBERG 2000 R. Rosenberg, *Beschreibungen und Nachzeichnungen der Skulpturen Michelangelos: Eine Geschichte der Kunstbetrachtung*, Munich/Berlin, 2000

ROTTERDAM 1948 *Tekeningen van Jan van Eyck tot Rubens*, Rotterdam (Museum Boijmans), 1948–9

ROTTERDAM 2001 A.W.F.M. Meij and M. de Haan, *Rubens, Jordaens, Van Dyck and their Circle: Flemish Master Drawings from the Museum Boijmans van Beuningen*, exh. cat., Rotterdam (Museum Boijmans van Beuningen), 2001

ROYALTON-KISCH 1986 M. Royalton-Kisch, 'Netherlandish drawings at Edinburgh' [review of Andrews 1985a], *Apollo* 123 (1986), pp.362–3

RUTGERS 2012 J. Rutgers, 'Jacob Jordaens and printmaking in Antwerp in the seventeenth century', in Münch/Pataki 2012, pp.291–323

SCHAPELHOUMAN/SCHOLTEN 2009 M. Schapelhouman and F. Scholten, 'Acquisitions: Eleven drawings and a statue: a selection from the Van Regteren Altena Donation', *Rijksmuseum Bulletin* 57 (2009), pp.88–110

SCHARF 1949 A. Scharf, 'An exhibition of Flemish drawings', *The Burlington Magazine* 91 (1949), pp.138–9

SEVERINO 1594 R.P.F. Severino, *De vita miracvlis et actis canonizationis Sancti Hyacinthi [...]*, Rome: Gabiana, 1594

STEADMAN 1982 D.W. Steadman, *Abraham van Diepenbeeck: Seventeenth-century Flemish Painter (Studies in Baroque Art History 5)*, Ann Arbor, 1982

STUART WORTLEY 1937 C. Stuart Wortley, 'Anthonie van Dyck (1599–1641): portrait of a man', *Old Master Drawings* 12 (1937), pp.26–8

SYDNEY 2015 Michael Clarke (ed.), *The Greats: Masterpieces from the National Galleries of Scotland*, exh. cat., Sydney (Art Gallery of New South Wales), 2015–16

TEL AVIV 1995 D.J. Lurie, *Van Dyck and His Age*, exh. cat., Tel Aviv (Tel Aviv Museum of Art), 1995–6

TIJS 1983 R.J. Tijs, *P.P. Rubens en J. Jordaens: Barok in eigen huis. Een architectuurhistorische studie over groei, verval en restauratie van twee 17de-eeuwse kunstenaarswoningen in Antwerpen*, Antwerp, 1983

TÜMPEL 1993 C. Tümpel, 'Jordaens: a Protestant artist in a Catholic stronghold', in Antwerp 1993, vol.1, pp.31–7

TURNER 2002 S. Turner, *Anthony van Dyck (The New Hollstein Dutch & Flemish Etchings, Engravings and Woodcuts 1450–1700)*, 8 vols, Rotterdam, 2002

VAN DE VELDE/VLIEGHE 1969 C. Van de Velde and H. Vlieghe, *Stadsversieringen te Gent in 1635 voor de Blijde Intrede van de Kardinaal-Infant*, Ghent, 1969

VEY 1962 H. Vey, *Die Zeichnungen Anton van Dycks*, 2 vols, Brussels, 1962

VLIEGHE 1972 H. Vlieghe, 'Enkele getekende Modelli door Cornelis Schut', *Gentse Bijdragen tot de Kunstgeschiedenis en de Oudheidkunde* 22 (1969–72), pp.183–97

VLIEGHE 1987 H. Vlieghe, *Rubens: Portraits of Identified Sitters Painted in Antwerp (CRLB XIX, 2)*, London, 1987

VLIEGHE 1993 H. Vlieghe, 'Rubens's atelier and history painting in Flanders: a review of the evidence', in P.C. Sutton (ed.), *The Age of Rubens*, exh. cat., Boston (Museum of Fine Arts)/Toledo (Museum of Art), 1993–4, pp.158–70

VLIEGHE 1996 H. Vlieghe, 'Cossiers, Jan', in J. Turner (ed.), *The Dictionary of Art*, 34 vols, London/New York, 1996, vol.8, pp.1–2

VLIEGHE 1998 H. Vlieghe, *Flemish Art and Architecture 1585–1700 (Pelican History of Art)*, New Haven/London, 1998

DE VRIES 1991 L. de Vries, 'Jan Boeckhorst', *Kunstchronik* 44 (1991), pp.262–66

WASHINGTON 1990 A.K. Wheelock, Jr et al., *Anthony van Dyck*, exh. cat., Washington (National Gallery of Art) 1990–1

WASHINGTON/FORT WORTH 1990 H. Macandrew, *Old Master Drawings from the National Gallery of Scotland*, exh. cat., Washington (National Gallery of Art)/Fort Worth (Kimbell Art Museum), 1990–1

WELLESLEY/CLEVELAND 1993 A.-M. Logan, *Flemish Drawings in the Age of Rubens: Selected Works from American Collections*, exh. cat., Wellesley (Davis Museum and Cultural Center)/ Cleveland (The Cleveland Museum of Art), 1993–4

WETHEY 1975 H. Wethey, *The Paintings of Titian. III: The Mythologial and Historical Paintings*, London, 1975

WHITE 1960 C. White, 'Van Dyck drawings and sketches', *The Burlington Magazine* 102 (1960), pp.510–16

WHITE 2005 C. White, 'Peter Paul Rubens: the drawings', *Master Drawings* 43 (2005), pp.213–16

WILMERS 1996 G. Wilmers, *Cornelis Schut (1597–1655): A Flemish Painter of the High Baroque*, Turnhout, 1996

WILSON 1994 M.I. Wilson, *Nicholas Lanier: Master of the King's Musick*, Brookfield, 1994

WOOD 1990 J. Wood, 'Padre Resta's Flemish drawings: Van Diepenbeeck, Van Thulden, Rubens, and the School of Fontainebleau', *Master Drawings* 28 (1990), pp.3–53

WOOD 2003 J. Wood, 'Nicholas Lanier (1588–1666) and the origins of drawings collecting in Stuart England', in C. Baker, C. Elam and G. Warwick (eds), *Collecting Prints & Drawings in Europe*, Aldershot, 2003, pp.85–121

WOOD 2010A J. Wood, *Rubens: Copies and Adaptations from Renaissance and Later Artists: Italian Artists (CRLB XXVI, 2): I. Raphael and his School*, 2 vols, Turnhout, 2010

WOOD 2010B J. Wood, *Rubens: Copies and Adaptations from Renaissance and Later Artists: Italian Artists (CRLB XXVI, 2): II. Titian and North Italian Art*, 2 vols, Turnhout, 2010

WOOD 2011 J. Wood, *Rubens: Copies and Adaptations from Renaissance and Later Artists: Italian Artists (CRLB XXVI, 2): III. Artists Working in Central Italy and France*, 2 vols, London/Turnhout, 2011

Acknowledgements

I wish to thank the teams at the National Galleries of Scotland involved in *Rubens & Company*, in particular the Art Handling Team, James Berry, Michael Clarke, Julie Duffy, Kerry Horsburgh, Sam Lagneau, Steven Morgan, Charlotte Park, Jacqueline Ridge, Helen Smailes, William Snow, Lesley Stevenson, Graham Taylor, Alice Tod and Graeme Yule. Graeme Gollan examined the works and captured watermarks and Aidan Weston-Lewis discussed Rubens's Italian drawings with me. Gillian Achurch, Jennifer McIlreavy, Christine Thompson and Sarah Worrall expertly saw through the production of this book, beautifully designed by Robert Dalrymple.

I am grateful for advice and support generously received from Angelamaria Aceto, Marten Jan Bok, Koen Brosens, An Van Camp, Hugo Chapman, Thomas le Claire, Bas Dudok van Heel, Peter Fuhring, Maria Galen, Peter Humfrey, Joachim Jacoby, Margret Klinge, Friso Lammertse, Erik Löffler, Harm Nijboer, Sarah Van Ooteghem, Sheldon Peck, Michiel Plomp, Jaco Rutgers, Peter Schatborn, Alexander Strasoldo, Cécile Tainturier, Ilona van Tuinen, Simon Turner, Alejandro Vergara, Hans Vlieghe, Susanne Wagini, and Robert Wenley.

The support of Victor Alers, a research master's student from Utrecht who spent a six-month internship at the Scottish National Gallery in 2015–6, was indispensable and I am immensely grateful for his patience and flexibility.

Warm thanks go to Anne-Marie Logan who generously shared her vast knowledge about Rubens's drawings and to Stijn Alsteens who kindly commented on the draft catalogue entries, despite being very busy with the final stages of his own exhibition at the Frick Collection.

My final thanks go to Nic Van der Marliere and Lukas Van Damme from the General Representation of the Government of Flanders in the UK for generously supporting this publication – and to Martin Adam and William Zachs for making all the difference. CTS